IMAGES
of America

ROGUE RIVER

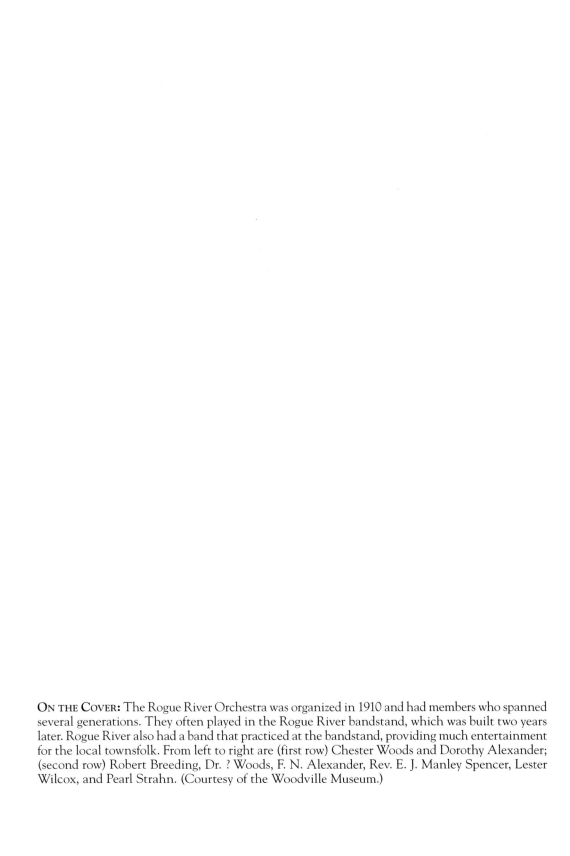

IMAGES
of America

ROGUE RIVER

Cheryl Martin Sund

ARCADIA
PUBLISHING

Published by Arcadia Publishing
Charleston SC, Chicago IL, Portsmouth NH, San Francisco CA

Printed in the United States of America

Library of Congress Control Number: 2009924713

For all general information contact Arcadia Publishing at:
Telephone 843-853-2070
Fax 843-853-0044
E-mail sales@arcadiapublishing.com
For customer service and orders:
Toll-Free 1-888-313-2665

Visit us on the Internet at www.arcadiapublishing.com

Dedicated to all who open these pages and all whose stories are told here.
God bless America!

CONTENTS

ACKNOWLEDGMENTS

The author is indebted to the Woodville Museum, who allowed access to all their files, photographs, and, best of all, the back storeroom so that I could uncover many exciting tidbits about Rogue River's history. Without all the wonderful volunteers there, this book would not exist.

Thank you also to the many local residents who shared their memories and their photographs and helped me fill in missing moments in time. My brothers and my sister—Jim, Fred, Carl, Don, Lawrence, and Sharon—were a great help in identifying people and places in many of the old, unmarked photographs and in clarifying the timeline of Rogue River.

Last but definitely not least, my love and thanks to my husband, Bruce, who helped me where my computer skills were lacking and made his own dinner on countless occasions; also thanks to my friends Nona and Judy and daughters Sara and Libby, who encouraged me and told me "You can do it!" on more than one occasion. To my grandsons Cole and Evan—this is for you!

To my editor, Sarah Higginbotham, what a joy you have been to work with. You kept me on track and made the entire process run smoothly. Thank you a million times!

I would also like to acknowledge my parents, James and Lottie Martin, who kept the stories of our family and of the valley alive for so long. They taught all their children to be patriotic, to believe in God, and to be curious about our history. Because of them, I realize the importance of preserving our stories to pass on to future generations.

In this book, the names Tailholt, Woodville, and Rogue River are used interchangeably. They all mean the same place, our wonderful little city of Rogue River. This book only scratches the surface and does not intentionally leave out anyone or any period of time. There simply is too much to cover in one book.

Unless otherwise noted, all images appear courtesy of the Woodville Museum.

INTRODUCTION

The story of Rogue River, Oregon, began long before it was actually incorporated as a city in 1912. Even before 1846, a narrow path worn by fur trappers and traders made its way from the Willamette Valley through the southern Oregon area and down into the gold fields of California. A party of explorers, including the famous Applegate brothers, widened the path and established a wagon trail through southern Oregon, over the Cascade Mountains to Fort Hall. The original party of 15 members then led a group back over the trail to the Willamette Valley, and it is believed that one of those travelers decided to make his home on the site between two streams, later known as Evans Creek and Wards Creek, both in the heart of Rogue River.

The Native Americans of the area were collectively called the Rogues. Those closest to what is now Rogue River were the Takelmas, meaning "those dwelling along the river." They were friendly, and the first settlers had no problems with them until the early 1850s, when the first skirmish is recorded. As more and more people traveled from the North Country of Oregon to the gold fields of California, the immigrants quickly wore out their welcome. Most of those traveling through had gold fever and were not about to let anyone get in their way. When gold was discovered in the Rogue River and surrounding creeks, greed and jealousy came into play. The combination of rich farmland and gold-bearing creeks made the valley highly desirable to the white travelers. Their prospecting muddied the creeks in which the Native Americans fished, they cut down the oak trees that the Native Americans depended on for acorns, and they decimated the deer and elk herds needed for food. Little by little, the Native Americans lost much of their land, their food, and the precious freedom they had known. The Native Americans decided to fight.

The first outbreak occurred in 1853 and was short-lived, ending with the signing of a treaty that same year that established the Table Rock Indian Reservation, near present-day Medford, Oregon. Two years later, trouble again broke out as the Native Americans tried to maintain their way of life. For nine months, through a harsh winter, they fought a continuous battle. Finally in May 1856, the nearly starving Native Americans were defeated at the Battle of Big Meadows at the Big Bend of the Rogue River. After they surrendered, they were shipped off to the Siletz and Grande Ronde Reservations.

During the Indian Wars, many of the white settlers left the area for more secure homesteading. Chinese miners moved into the area and had great success mining the creeks that others had left behind. By the late 1850s, a number of whites returning from the gold fields of California saw the success of the Chinese miners. Soon Evans Valley, along with other tributaries of the Rogue River, was so filled with the white prospectors that the Chinese were driven out.

Davis Evans was one of the first known settlers of the Rogue River area. In 1851, he built two cabins and a rustic ferry at the Rogue River crossing called Tailholt. Miners and fur traders traveling between the Willamette Valley and the gold fields of California discovered that the safest and easiest way to cross the river was to get a good grip on their horses' tail and swim behind the animal, hence the name "Tailholt." It was also the cheapest way to cross the river, as they

were able to avoid ferry fees. The ferryboat Evans built had a deck 8 feet wide and 45 feet long. He anchored the cable to the north bank of the river, and on the south side, he anchored to a pile of rock on a gravel bar. Evans charged travelers $1.50 for a loaded wagon; $1 for an empty wagon; 25¢ for a horse and rider, a yoke of oxen, or a loaded animal; 12½¢ for a single person or animal, and 5¢ for every sheep or hog.

In 1855, the first post office was established under the name of Gold River with Davis Evans as the first postmaster. Evans also had the dubious nickname of "Coyote" Evans. It is said that he came by this name because of his card-playing skills as well as his methods of collecting on those gambling debts that others did not want to pay. The name "Gold River" did not last long, nor did Evans, as he soon moved upriver about 8 miles to buy a hotel at the area called Dardanelles.

Plenty of evidence still speaks to his presence, however, as a small park at the end of the bridge in Rogue River, near where his ferry was located, now bears his name—Coyote Evans Wayside—and the creek near there is named Evans Creek.

By 1860, the nucleus of a town had formed, consisting of a hotel, a livery barn, a stage depot, and a few houses. Soon after that time, a merchandise store opened operated by Joe Solomon. This grouping of businesses and homes became known as Woodville in 1872, named after John Woods.

The lumber for John Woods's home was sawn by Sam Steckel, who owned a water-powered sawmill about 4 miles up Evans Creek. Much of the lumber for the early buildings came from this mill, as well as timbers for the first covered bridges. By 1875, Steckel was processing up to 4,000 board feet of lumber a day using a circular saw. The first covered bridge across Evans Creek, near its confluence into the Rogue River, was built in 1868, repaired in 1883, and dismantled in about 1912. Its 80-foot timbers were found to be in such good condition they were moved upstream about 7 miles and used to build another covered bridge—the Minthorn Bridge. That bridge withstood much high water but finally washed away in the flood of 1964, shortly before it was slated to be demolished. During the flood, several men of the valley tried to get cables around the bridge to anchor it to the bank, but all efforts failed and the bridge was lost.

In 1910, the town of Woodville incorporated and Sam Mathis became its first mayor. He was responsible for much of the beautification of the town, including the building of the bandstand at the triangle in the center of town. He owned many rental homes in town, and when he died in 1941, he left them to his tenants.

A new jail, new bridges, and a new elementary school had been built by 1912, and the people of the town wanted to advertise the river and attract tourism. In April 1912, it was voted to change the name from Woodville to the City of Rogue River.

One

THANKS TO
T. H. B. TAYLOR

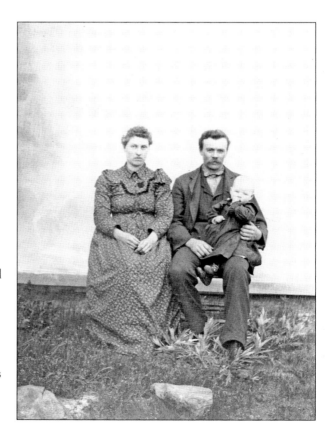

T. H. B. Taylor took many of the photographs in this book after he settled in Evans Valley in 1877. Some were donated to the Woodville Museum by his grandson Rollin Taylor, and others were purchased at an estate sale. Because much of Rogue River's history would be unknown were it not for these photographs, this first chapter is about the Taylor family. T. H. B. Taylor was a prolific photographer, and there are many pictures of his family; however, only one tiny image could be found of him. In this photograph taken in 1899, T. H. B. Taylor's son, Harry, poses with his wife, Birdie, and son Rollin.

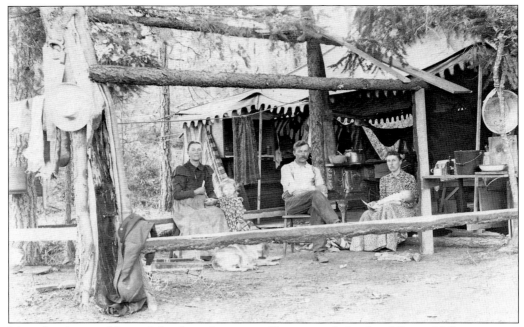

Many families would travel the short distance to Placer, near Leland and Sunny Valley, to set up temporary mining camps. Shown here at their camp is Grandma Florence Taylor with Rollin at her knee, Harry, and Birdie holding Rollin's new baby sister, Beulah.

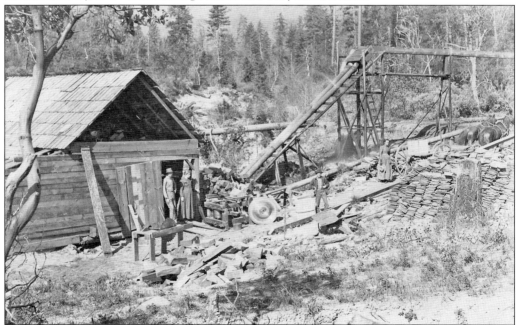

The Taylors operated the shake mill on Queens Branch Road in Evans Valley. Harry and Birdie Taylor, along with Mr. McPherson, put in long hours splitting shakes. The woman on the far right is just listed as "Grandma" on the back of the photograph, so it is most likely Florence Taylor. It was here that the shakes for the Presbyterian church in Woodville were split in 1903.

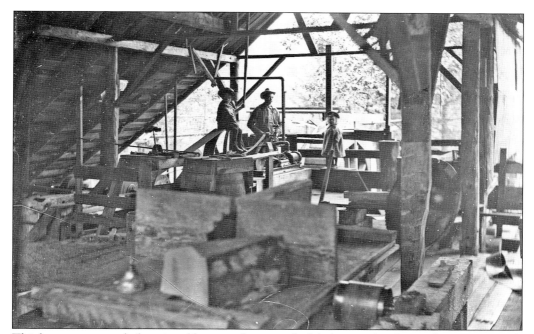

This barn was not only functional but was also a wonderful place to play. Located on Bear Branch Creek by the Taylors' big white house, it stood strong until it burned in the 1980s. Shown here is Harry Taylor with his children, Rollin and Beulah, in 1902 or 1903.

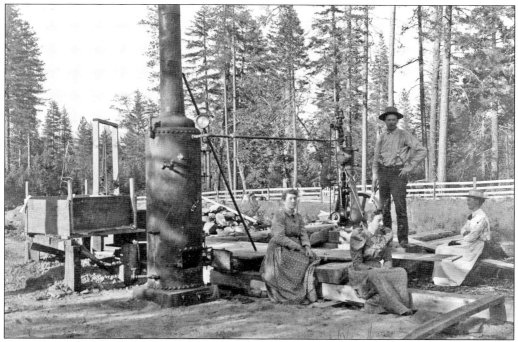

July 1898 found Harry (standing) and (from left to right) Birdie Taylor, Sabery Booker, and Grandma Taylor on the Queens Branch property. This appears to be some sort of steam-generated wood splitter or saw. Note the wrench in Harry's hand.

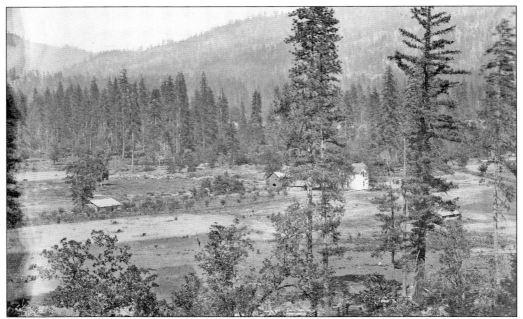

In a 1983 letter from Rollin Taylor, he says, "My grandfather and family, T. H. B. Taylor and great-grandfather Booker [Hathaway Booker] settled on Bear Branch Creek where the two story white house is in 1877." T. H. B. Taylor later bought the old Woods house in Rogue River (then Woodville) and built the Waldorf Hotel. According to letters, he bought the Woods house and property for $100.

This is the home built by T. H. B. Taylor in 1877 on Bear Branch Creek. The home is still standing today and has been beautifully restored. Tragically, the historic barn that once graced the property burned in the 1980s. According to the writing on the back, the people shown are Birdie Taylor, Rollin Taylor in buggy, Mrs. Hopwood, Grandma and Harry Taylor, and Sabery Booker.

This is the wedding picture of Rollin Taylor and his bride, Cora, taken in 1925. After Cora's death, Rollin married a woman named Frankie, and they ran an antique shop in Maricopa, California.

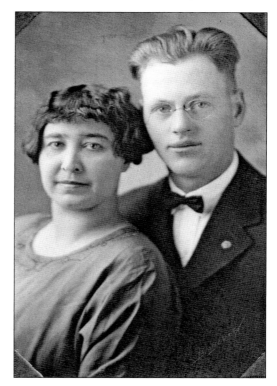

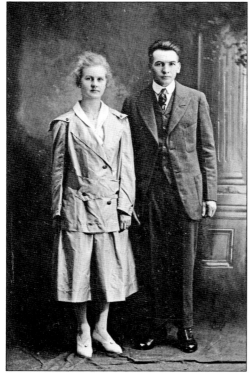

Beulah Taylor and Wiley Knighton's wedding photograph was taken in 1918. Beulah was the sister of Rollin Taylor.

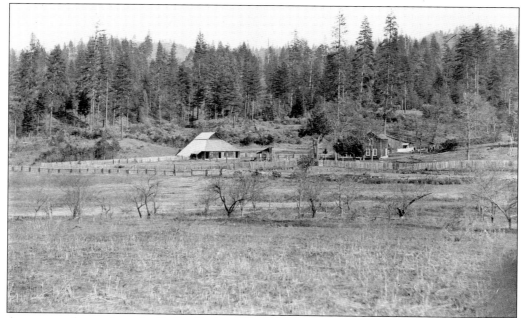

An excerpt from a letter by Rollin Taylor said, "Grandfather Osborn and family settled what is known as Starvation Heights in 1883." Located about halfway between Rogue River and Wimer, and at a slightly higher elevation than the surrounding area, Starvation Heights gained its name because of the poor granite-like soil in which it was hard to grow a crop. It was more barren with scrubby vegetation compared to rich soil on either side of the rise, and many people who tried to settle there eventually "starved out."

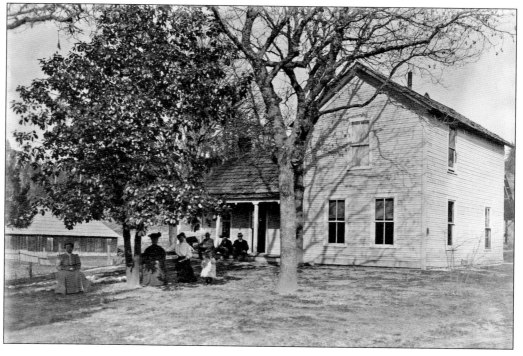

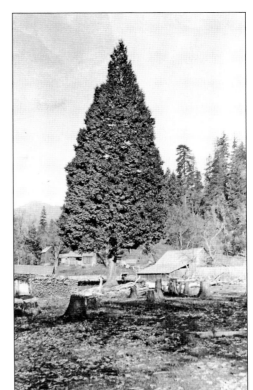

Rollin Taylor, age eight, is pictured at his Grandfather Osborn's place on Starvation Heights in 1906. Note the beautiful and very labor-intensive split-rail fence around the field on the left of the photograph below. The Martin boys of Wimer recall riding their horses the 7 miles to Rogue River and going through these open, nearly treeless fields. Very little of the meadows are left now. The area is now covered with large pine and fir trees, and many homes have been built.

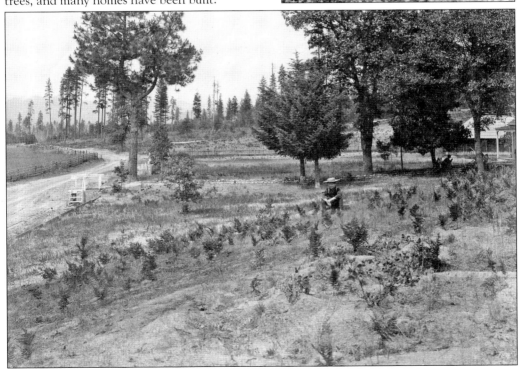

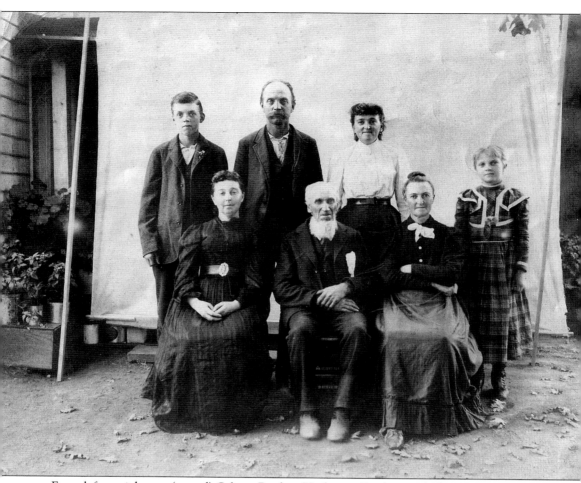

From left to right are (seated) Sabery Booker, Hathaway Booker, and Florence Booker Taylor; (standing) Jeff Wimer Jr. and Jeff, Georgia, and Carlie Wimer. Hathaway was the father of the three women in the photograph. T. H. B. Taylor, husband of Florence, took this photograph. Born in Marion County, Illinois, on May 18, 1842, he enlisted for service in the Civil War but was discharged after being seriously wounded in the shoulder in the Battle of Pittsburg Landing. In 1863, he re-enlisted, receiving his honorable discharge in 1865. In 1876, he came to Oregon and soon bought his farm in the Evans Creek Valley. According to the 1912 *The Centennial History of Oregon*, "At the time he purchased this farm it was in a very primitive state but by hard labor and continuous effort during his occupancy, he succeeded in placing the greater part of it under a good state of cultivation and erecting suitable improvements." Taylor married Florence E. Booker, a native of Maine, in 1869. They had one son, E. H. B. (called Harry, father of Rollin).

Two

A Town with Three Names

The city orchestra often went to the depot to greet the passengers with music as they disembarked from the train. Pictured here from left to right are (first row) Chester Woods, Dorothy Alexander, and Harvey Woods; (second row) Mrs. Woods, Robert Breeding, Dr. Woods, F. N. Alexander, Rev. E. J. Manley Spencer, Lester Wilcox, Pearl Strahn, Harlan Davie, Warren Evans, and E. R. Lake.

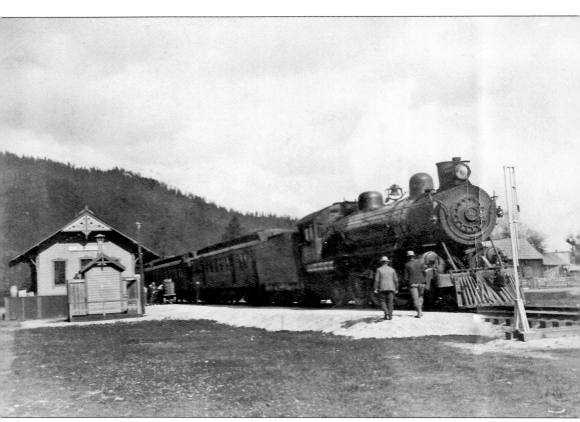

There were two train depots in Woodville. The first was built in 1887 on the south side of the railroad tracks where the freeway now is. The sign on the building said "Woodville" and stated the distance to Portland and San Francisco. The engine parked beside the depot is "Skunk." It was said that those who rode it would soon know the reason for its name. A passenger car and engine all in one, it served the Rogue Valley for many years, running between Ashland and Grants Pass. Juanita Skevington Martin recalled waiting for the mail as a child. There was a pole with a hook by the tracks. Because the train did not always stop in Woodville, the outgoing mail was placed in a bag and hung on the hook. As the train rolled slowly by, the bag would be pulled into the car and the bag of incoming mail would be tossed out onto the platform. The postmaster then allowed the children to help load it into his wooden mail cart and roll it to the post office.

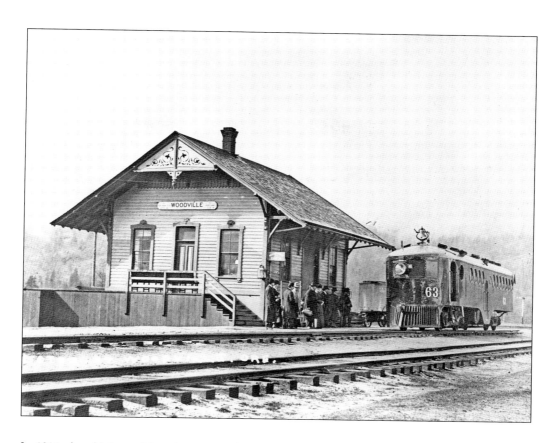

In 1914, the old depot (above) was torn down and a new one (below) was built on the north side of the tracks. It remained in use until in the 1940s (some accounts say it was the 1930s), when it was partially torn down and moved to its present location on East Main Street. It was remodeled into a home by the Randleman family, was used as an antique shop for a while, and is currently a restaurant.

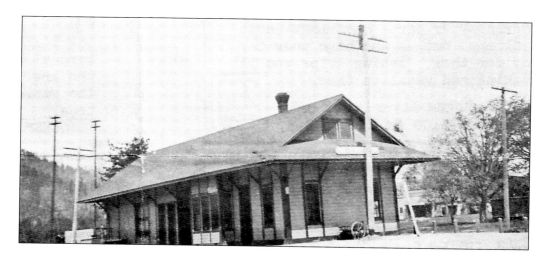

What a difference 50 years can make. These two photographs show Depot Street, viewed from opposite ends of the street and approximately 50 years apart. The photograph below is looking north and was taken in 1952 from atop the Bristol Silica plant. The above photograph was taken from the area known as "the Triangle" and was taken about 1911. The train depot is the building on the far right.

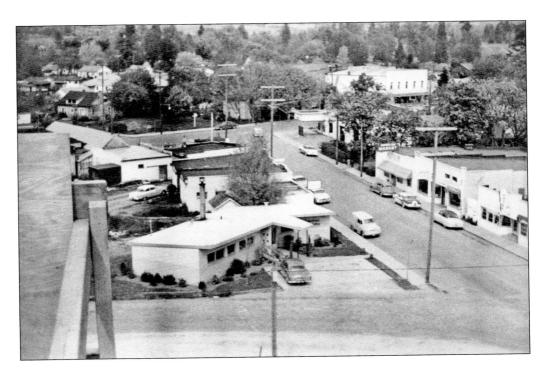

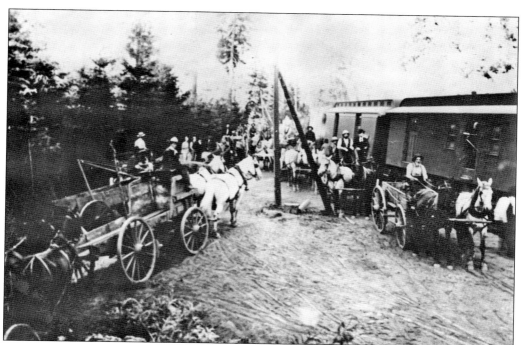

A very early photograph of Rogue River (Tailholt at that time) shows a busy shipping day at the railroad. Notice the number of horses and wagons and imagine the chaos.

These men seem to be dressed too nicely to be working on the railroad, but note all the shovels on the far left cart. Shown are, from left to right, Roy Seaman, Billy Sams, Lloyd Seaman, Raymond Stevens, ? Hodkins (boss), Henry Breeding, Robert Breeding, and Billy Kinney (flagman). The year was 1909.

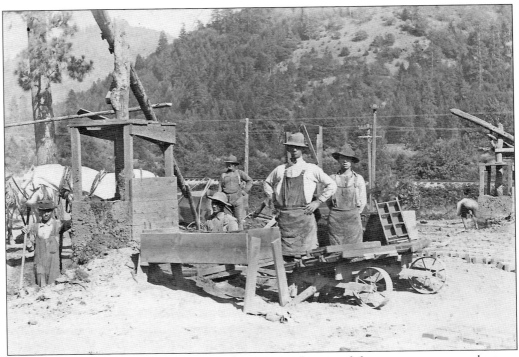

The Horton family ran a brickyard on what is now the site of the water treatment plant on Foothill Boulevard. They manufactured the bricks for many area buildings, including the new elementary school that was built in 1909. According to Dale Hatch, the area was a field of brush and chaparral and the ground had a lot of clay in it, making it perfect for bricks. The moistened clay was shaped into bricks in wooden forms and dried in the sun. In the center below holding a brick form is Frank Hall. From left to right are Jimmy Heir, Hall, Chauncey McClellan, Fred Horton, and C. W. Horton.

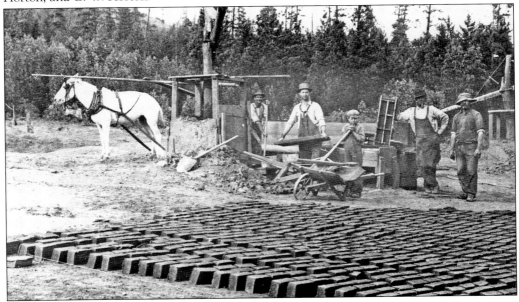

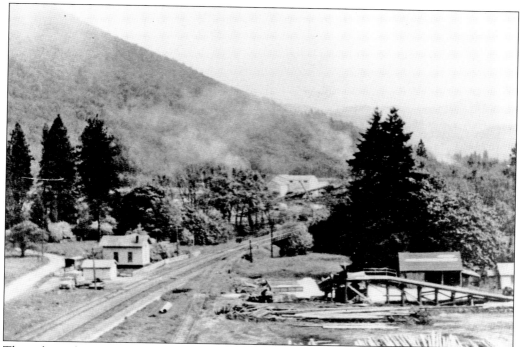

The pole yard was located on the south side of the railroad tracks, approximately where the off-ramp of the freeway is located now. This photograph was taken in the 1940s or 1950s, and the mill can be seen in the background.

According to a note and photograph donated to the museum by Willis Stiehl, this stamp mill sat on the town side of the river, approximately where the freeway is now. The mill was used to separate the gold from the ore by stamping the ore, then placing it on a shaker. The gold would be separated, and if other minerals were present, it would go through the same process with a shaker of a different size.

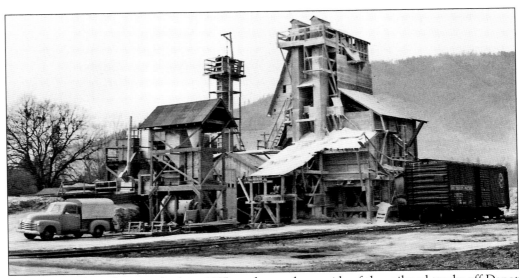

The Bristol Silica plant was built in 1937 on the southwest side of the railroad tracks off Depot Street. It provided a year-round source of employment for many of the local men. In January 1955, the State Department of Geology and Mineral Industries issued a report regarding Oregon's mineral industry in 1954. It stated, "Bristol Silica is the sole producer of silica in the state. To meet the increasing demand for their high quality product, the company completed installation of a new rod mill, extra screening capacity and a washing plant this year." It went on to say that F. I. Bristol, owner, reported that Northwest metallurgical plants used his silica in the manufacture of silicon metal, ferrosilicon, and silicon carbide. He also developed a new market for crushed silica for roofing. The plant was forced to relocate to North River Road when the freeway was built in the early 1960s. It is still in operation today.

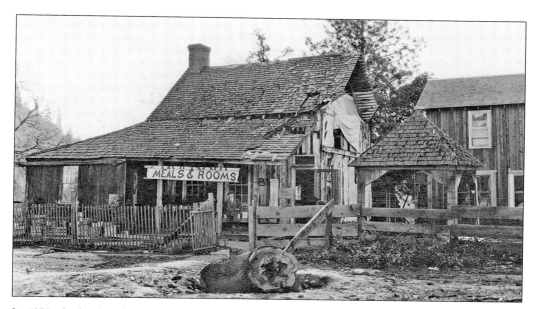

In 1872, the lumber for the John Woods home was sawn at Sam Steckel's mill. This was the first home in Rogue River (then Tailholt), and soon the name of the town was changed to Woodville. It was used as an unofficial stage stop, and Woods kept a livery stable across the street. Over the years, the building evolved and was added on to. T. H. B. Taylor acquired the property on January 1, 1910, and according to his diary, he "began keeping hotel in Woods house" on April 24. Over the next two years, he worked on another building, and on January 12, 1912, he opened the Waldorf Rooms.

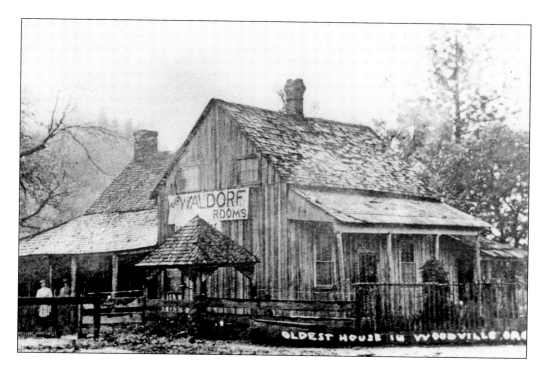

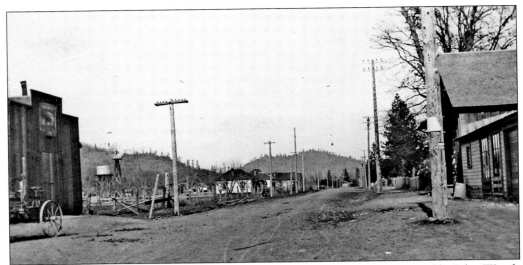

At the northwest corner of Main and Pine Streets was the livery stable operated by John Woods while he lived in his home on the southwest corner. Across the street was a hall that was often used for dances (right side of photograph). In the 1930s, the building was used as a garage operated by Clint Hawkins. It was torn down and replaced by a VFW (Veterans of Foreign Wars) Hall in 1947. Thirty years later in 1977, the building was once again replaced, this time by Evergreen Bank.

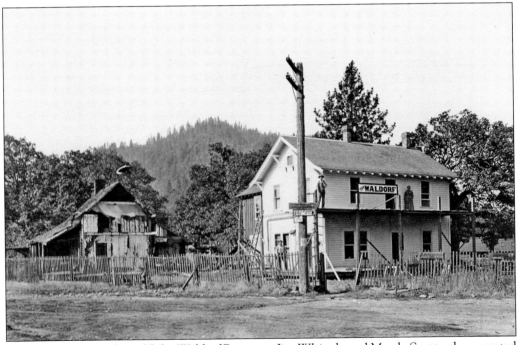

In 1926, T. H. B. Taylor sold the Waldorf Rooms to Jim Whipple and Myrtle Scott, who operated it until 1945, when it was sold it to Mr. and Mrs. Waller. A November 1953 newspaper clipping advertises rooms for $25 and apartments for $30 and up. It was operated under the name of Waller's Inn until it was torn down in 1967.

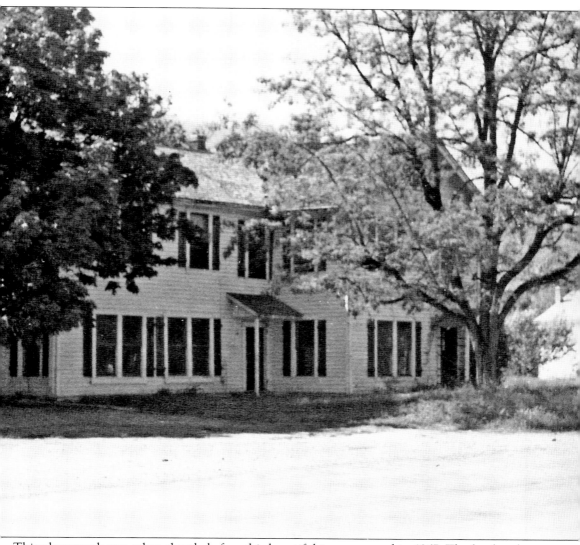

This photograph was taken shortly before this beautiful inn was razed in 1967. The landmark building was torn down and replaced by a service station and office building. The old oak trees that graced the lot and shaded many a guest at the inn were also removed. When T. H. B. Taylor tore down the original building on the lot, the Woods house, he used some of the lumber from the old structure to line the upstairs rooms of this building.

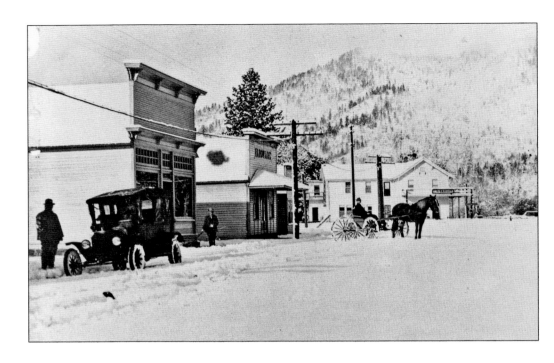

Just imagine the muddy mess this snow would have caused on the dirt streets of Rogue River. The 1916 photograph above and the 1940 photograph below both show dirt streets with Waller's Inn (Waldorf Rooms) at the end of Main Street. Only 24 years have passed between the taking of the two photographs, and the buildings are still the same, but the lower one looks much more modern.

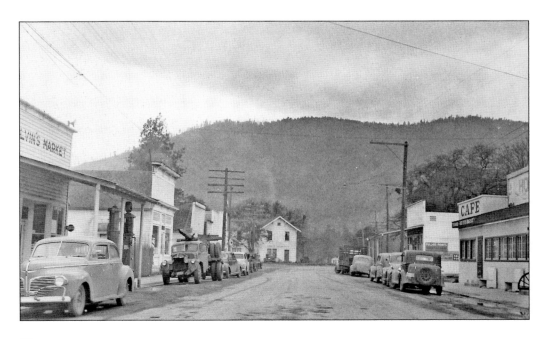

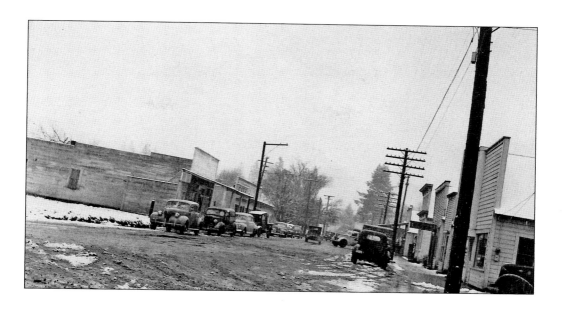

Standing in front of Waller's Inn and looking east on Main Street, one can see the amazing difference that only 20 years can make. The above photograph was taken in April 1947 and shows a late spring snow. Muddy streets must have made for miserable traveling. The town does at least have some sidewalks. Approximately 20 years later in the mid- to late 1960s, the street is paved, the Homestead Bar and restaurant has a tall modern sign with a neon "H," and storefronts have been updated. Note also the difference in the power poles.

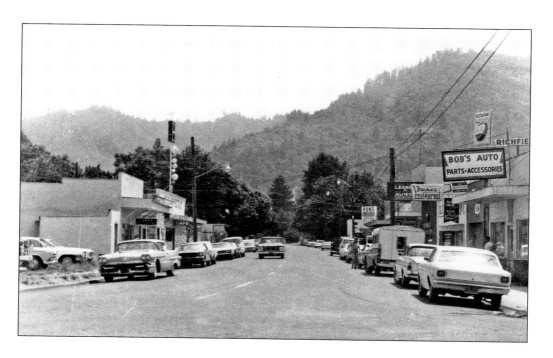

Ruby and Earl Weaver purchased a market on Depot Street in 1950 and ran it until 1960, when their son, Walter, and his wife, Lavina, took it over until 1970.

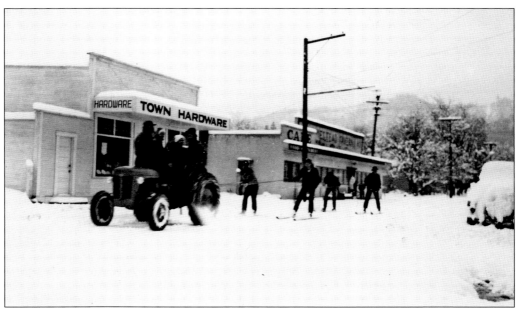

In the late 1940s or early 1950s, tractor skiing was a popular sport down Main Street. The boys would tie ropes to the back of the tractor, and four or five at a time would go sliding down the streets. This particular tractor is a Ford 9N.

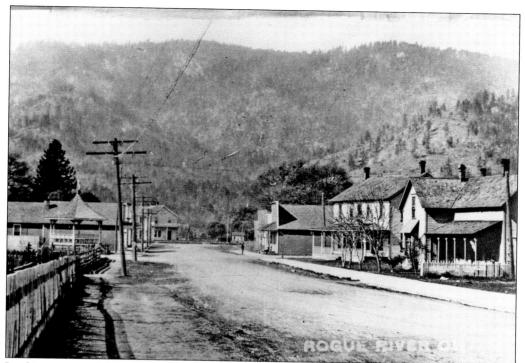

Looking west on Main Street, one can see the Waldorf Rooms at the end of the street. On the right is the Seaman house, and to its left is the Wilcox Hotel. On the left is the bandstand that was built in 1912. It was built as a place for the city band and orchestra to perform. It was moved in the 1940s to the park.

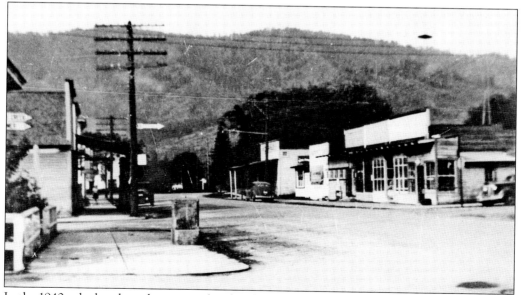

In the 1940s, the bandstand was moved and replaced by a rockwork drinking fountain that was in honor of Samuel Mathis, first mayor of Woodville when it incorporated in 1910. The inscription on the fountain read, "Dedicated to Samuel Mathis 1846–1941."

The current Homestead Tavern has been around almost as long as Rogue River. Opened in 1906 by Mark Whipple, the tavern did a thriving business until New Year's Day 1914, when the town "went dry," a prelude to Prohibition. During the dry years, the building was used as a grocery store then a meat market run by Burwell O'Kelly. By this time, the café and a real estate office had been added to the complex. Prohibition was repealed in 1933, so Ward Wills, who was running the café, turned the then-empty meat market into a pool hall and bar. He maintained the café as it was and named the whole complex the Homestead in 1935. It is still in operation today.

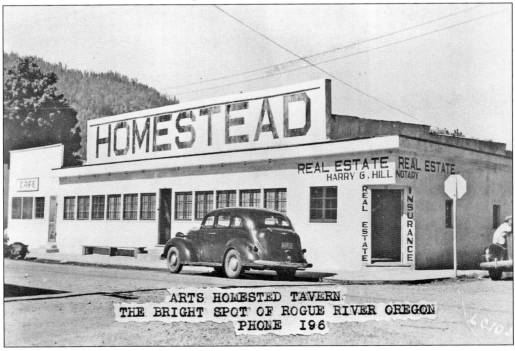

ARTS HOMESTED TAVERN.
THE BRIGHT SPOT OF ROGUE RIVER OREGON
PHONE 196

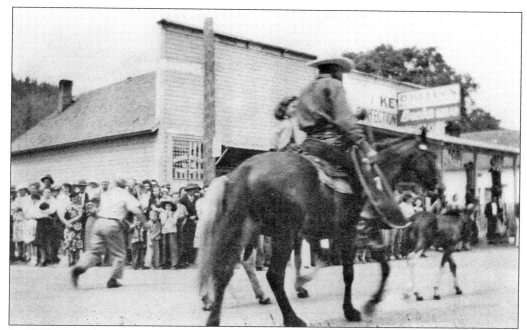

In 1945, a parade was a reason to come out and celebrate. James and Lottie Martin ride their horses down Main Street in front of O'Kelly's Market for the annual Forth of July parade.

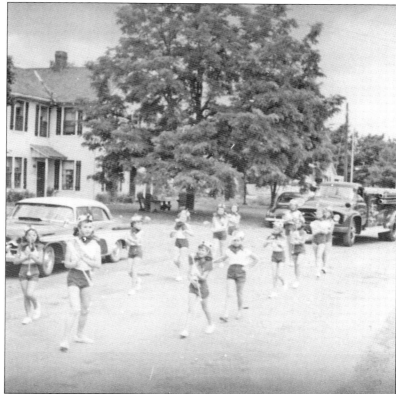

This is another parade, this time in front of Waller's Inn in the 1950s.

Both aluminum cans and Snow White debuted in 1937. Ward Wills displays the latest packaging of beer—aluminum cans—behind the bar at the Homestead in 1937. Two members of the city council and the mayor were facing recall over liquor license disputes. Wills and Andy Ballard applied for licenses for their places of business. Both were denied. Public sentiment was in favor of the beer parlors. A recall ensued against those who cast a "no" vote, Mayor Charles Hatch and councilmen Teed Cardin and William Milton. Hatch was recalled by a vote of 75-71, Cardin was recalled by a vote of 74-73, and Milton survived the recall by a vote of 78-66. A special election was called to fill the vacancies on the council. One day later, new council approved the licenses.

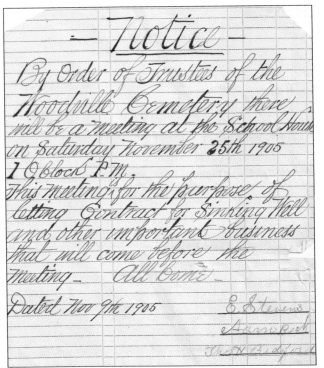

A public notice was posted on November 9, 1905, requesting all people attend a meeting of the cemetery trustees to discuss a contract for sinking a well and "other important business." The notice is signed by E. Stevens, Aaron Beck, and Thomas H. Bedford. The oldest headstone in Woodville Cemetery belongs to Bessie Schmidtline, who died April 13, 1886, though the ground was not officially used as a cemetery until 1889.

Elizabeth Fowler was quite the modern woman in the early part of the 1900s. She had the IOOF Building constructed, and when the Masons no longer used the upstairs part of the building, she converted it into apartments, one of which she lived in. This is her passport photograph, which would suggest she was also a traveler.

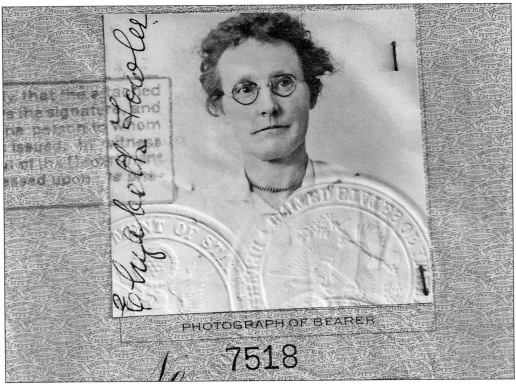

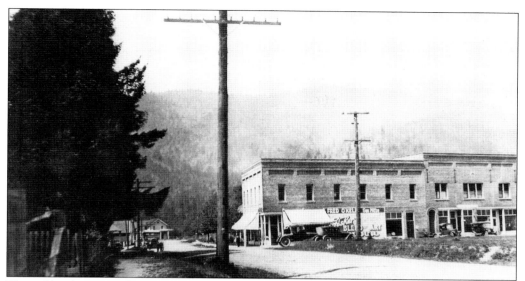

The red-brick store at the corner of Main and Broadway Streets was built in 1912 using handmade bricks. The top floor was a large hall used as a theater, basketball court, and dance hall. The store on the bottom floor was originally called Butler, Sluck, and Star General Store. In 1955, when the building was remodeled, it had a stucco facade applied over the bricks.

In 1914, a two-story building was erected at the back of the brick store for the International Order of Odd Fellows. Elizabeth Fowler lived upstairs, and Dr. W. S. Carey practiced downstairs. Willis Stiehl recalled that Dr. Carey had the habit of licking the needle before giving an injection to "make it go in easier." After Dr. Carey died, the fire department used the building for many years. Dr. Ron Dickey, who renovated it and has his veterinarian hospital there, currently owns the building.

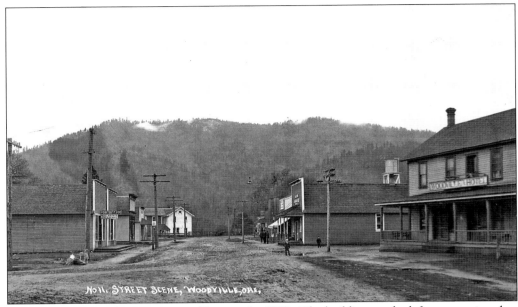

No. 11. STREET SCENE, WOODVILLE, ORE.

Rogue River's Main Street is pictured here in the 1930s. The building on the left sports a sign that reads "Post Office and real estate." On the right is the Woodville Hotel (also called the Wilcox Hotel and Pioneer Hotel at different times), built in the 1890s. It was torn down in the 1940s, and the lot stood vacant until the 1960s, when Carl Anderson constructed the present building, shown below. Note the large maple tree in the photograph below. It was planted in 1906 or 1907.

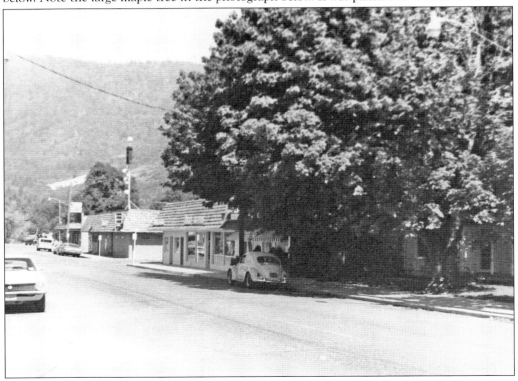

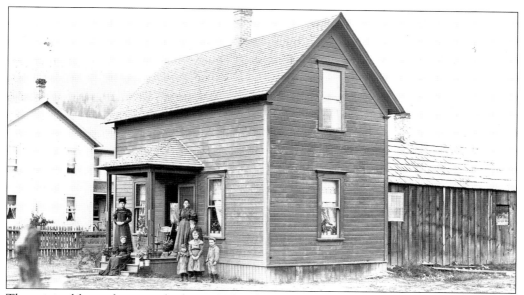

The original home here was built in 1895 and consisted of four rooms. It was built by Mattie Seaman, known throughout the town as Aunt Mattie. She was a widow who supported herself and her two young daughters by practical nursing and midwifery. Women from as far away as Grants Pass and Medford would come here to deliver their babies and be taken care of. The house was added on to over the years and was later occupied by Elizabeth Sheffield, who lived there from the mid-1940s to late 1970s. It is currently occupied as a real estate office.

Jack Bush (left) and Roy Moore (right) stand in front of the Seaman House. Note the beautiful bandstand in the background.

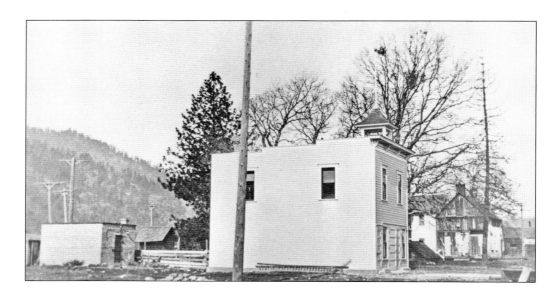

This building, constructed in 1910, was the home of the Rogue River Volunteer Fire Department until they moved to a new location in 1952. In the 1920s, the top floor was used as a city hall and by the library. After the fire department moved out, the building was converted into an apartment building for a short while but was soon demolished. The building currently on the same lot was a tire shop, operated first by Randy Miller and then by Dallas Chronister. It is currently a used car business. In the background of the above photograph, one can see the old jailhouse that was built of bricks from Horton's Brick Yard in 1911. It was later moved to the grounds of the Woodville Museum. Shown below are, from left to right, ? Jensen, the blacksmith; Dad Rule, the marshal; Mark Whipple, a saloonkeeper; John Smuck, depot agent; Jim Neathamer; and T. H. B. Taylor, proprietor of the Waldorf Rooms.

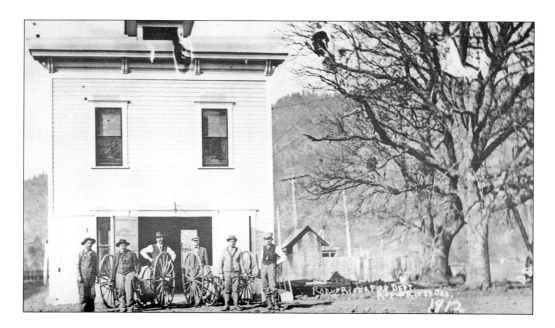

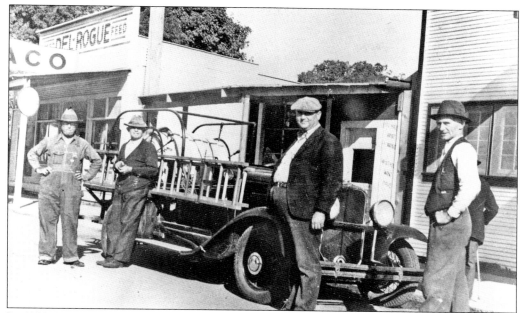

In 1938, Rogue River acquired its first motorized equipment. Standing in front of a renovated Marquette of the early 1930s are, from left to right, Nat Hart, Tom Smith, Al Osborne, and Tom Wilson. Notice Del Rogue Feed and Texaco at the left of the photograph.

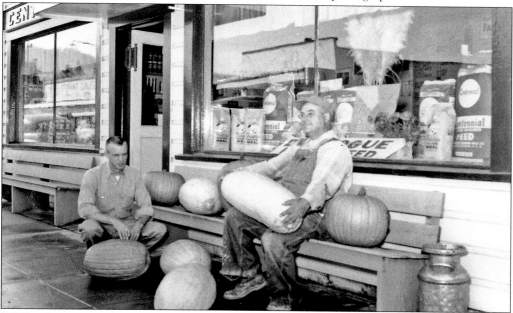

Bill Reeder, owner of the Del Rogue Feed store, is showing off a huge banana squash, along with some pumpkins and other winter squash. The first building on this site was a hardware store. It was replaced by a feed store in 1939 built by Leo and Lois Smith, which was taken over by Bill Reeder. A 1953 newspaper article stated that Reeder was selling out his feed and seed business, though he would retain ownership of the building. A series of businesses followed, including an auto parts shop, an antique store, and a real estate office.

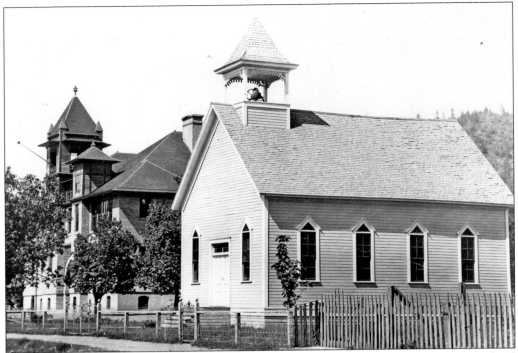

The Presbyterian church was built in 1903 on Pine Street next to where the elementary school is now located. In a letter, Rollin Taylor states that his grandfather, Thomas Taylor, sawed all the shingles for the roof of the church. He went on to tell of a man who broke his leg while working on the building. According to Taylor, the man said, "I guess the Lord was around on the other side of the building!" Shown here in 1910, it is next to the old elementary school that was built in 1909. The current Presbyterian church is located on Broadway Street.

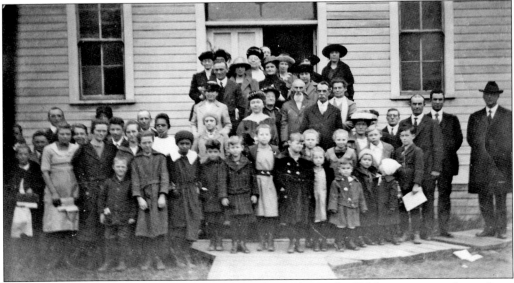

The congregation of the Presbyterian church in the early 1900s meets out front for a group picture.

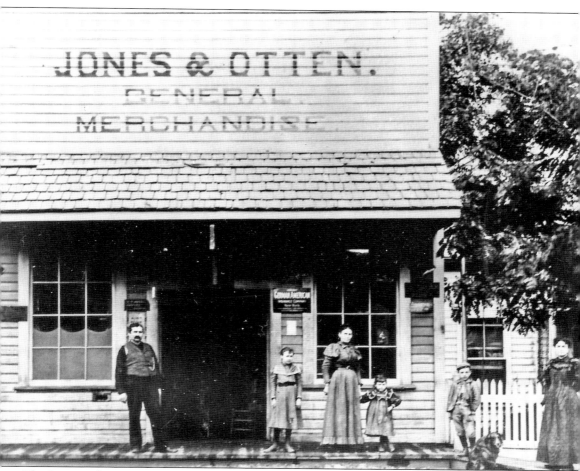

The Jones and Otten Store was built in the early 1890s. This picture was taken in 1896 or 1897 and shows, from left to right, W. V. Jones, Ada Jones, Mattie Seaman, Mary Jones, Dave Jones, and Cary Matthews Pennegar. The following quotes are from a letter written by Rollin Taylor to James Martin in 1989 and give a wonderful picture of the store: "The merchandise was scattered all over the place, including two cats, one blue and one gray. We can't forget Old Democrat, a big yellow shorthaired dog. He laid close to the front door and kept all the other dogs out of the store. He was everyone's pet and ate everything that was throwed out the back door. At the end of the counter was a slab of sowbelly. If you wanted a dimes worth Mr. Jones would cut off a piece for you. It was wrapped in brown paper. I especially remember the butcher knife he used. It was the same one he used to cut pieces of cheese off a 25 pound wheel."

In 1897, Joe Shults wed Minnie Mae King. He went on to become a police officer in 1933 in Rogue River. He was known as a colorful character, having only one leg and toting a Colt .45 revolver and a large flashlight. There seems to be some discrepancy as to the spelling of his last name; however, early documents uphold the Shults spelling and not "Schultz" as is written on the photograph below.

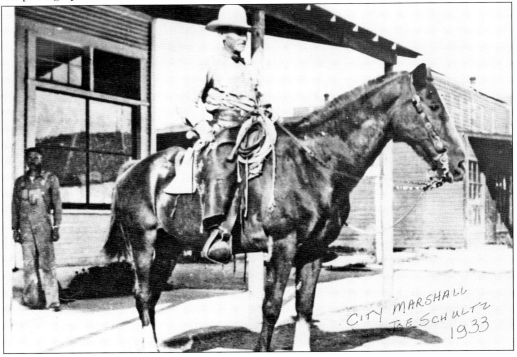

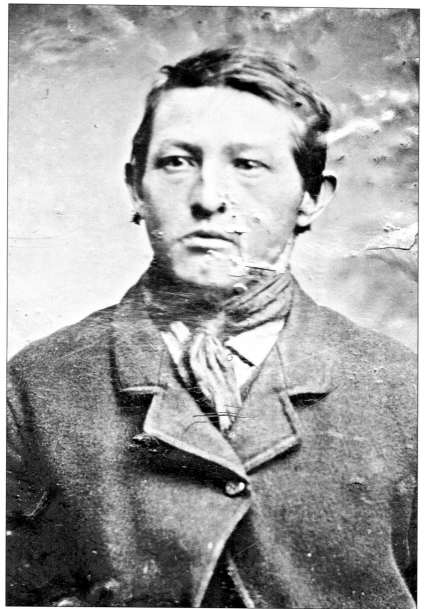

In 1850, Davis Evans built two cabins at the confluence of Evans Creek and the Rogue River. He built a rustic ferry out of three logs, each approximately 30 inches in diameter, and covered them with 2-inch planks. The ferry deck was about 8 feet by 45 feet. Davis charged $1.50 for a loaded wagon, $1 for an empty wagon, 25¢ for a horse and rider, and 12½¢ for a single person or animal. To escape the steep ferry fees, many people would just hold on to their horse's tail and swim across the river behind the animal, hence the first town name of Tailholt. Evans was a card shark and was not one who allowed debts to go unpaid, at least not debts owed to him. It is said that he used any means necessary to collect a debt, thus his dubious nickname, "Coyote." His mark remains, as the small park at the end of the bridge in Rogue River is now called Coyote Evans Wayside and the creek flowing past the town is called Evans Creek.

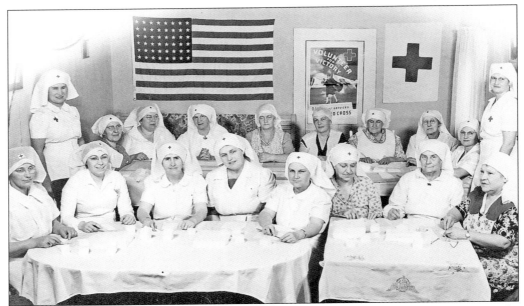

In 1943, the women of Rogue River had a Red Cross group and kept busy making bandages for World War II. Shown are, from left to right, (first row) Laura Dennis, Laura Laws, Lora Carter, Genevieve Dick, unidentified, Vivian Miller, Effie Badley, and Alice Dixon; (second row) Clarabelle Black, unidentified, Othella Strahn, Myrtle Whipple, Hadessa Mallenson, Violet Murphy, Zora Wiley (Lora Carter's mother), Elizabeth Fowler, Alma Shontz, and Lillian Hargitt.

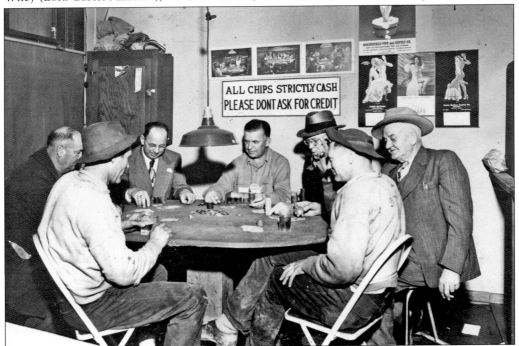

In 1949, the back room of the Homestead was always a good place to gather for a game of poker.

The grange hall, located on Gardiner Street, was built in 1956. It was constructed from a building that came from Camp White in White City. Camp White was built in 1941 as an army training camp. After the war, it was declared surplus and most of the buildings were sold at auction. The building has been renovated and updated several times and is still in use today.

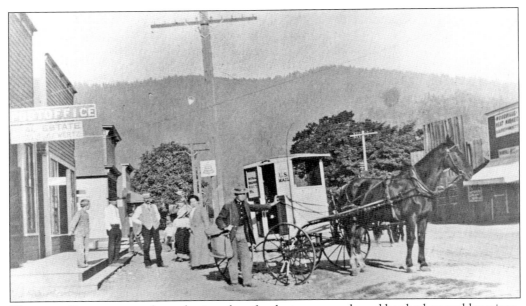

The post office was a popular gathering place for the townspeople and has had several locations. The first was at the John Woods home and was established in 1878. Until then, residents of Rogue River and Wimer had to travel to Rock Point (Gold Hill) to get their mail. The second location and the site of this photograph was on Main Street across from Jones and Otten Mercantile.

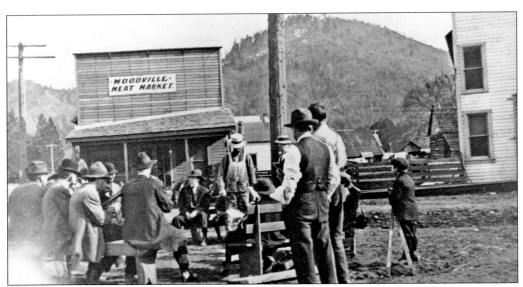

The first building at the northeast corner of Depot and Main Streets was the Woodville Meat Market. It too appears to be quite the gathering spot. It later operated as a livery stable and blacksmith shop. In 1946, this building was torn down and a service station was built. After the service station was removed in the early 21st century, a small city park with public restrooms was built. It now has a lovely water feature and grassy area.

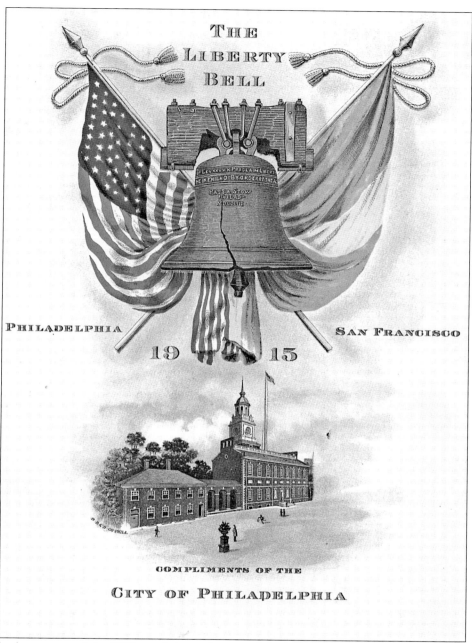

THE
LIBERTY
BELL

PHILADELPHIA SAN FRANCISCO

19 15

COMPLIMENTS OF THE

CITY OF PHILADELPHIA

In the latter part of the 1800s and the early part of the 1900s, the Liberty Bell was taken on "patriotic pilgrimages" so that all the people of the United States could see it. Rollin Taylor obtained this handbill in 1915 when the bell came through Rogue River. He would have been 17 years old at the time. The following note that accompanies the handbill describes his experience: "The bell was placed on a flat car for its journey from Philadelphia to San Francisco and was left uncovered for everyone to see. About twenty of us kids stayed at the depot until 1:00 o'clock in the morning to get to see the Liberty Bell. Cards like this one were thrown off by the guards as the train slowed down but didn't stop." The actual handbill is beautifully colored.

Pears were a profitable crop in southern Oregon, and Rogue River was no exception. This photograph was taken on the northeast side of Wards Creek in the early 1900s. Look closely (just left of center) to see the Wards Creek covered bridge. This area is now home to a doctor's complex, a dentist office, a restaurant, and many homes.

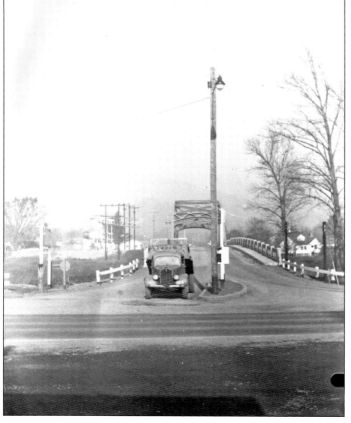

In 1952, a new fog light was installed at the entrance to the Rogue River bridge above the divider island. According to the local newspaper, "It is a new type, better than anything heretofore installed in Southern Oregon." Because of the proximity of the river, fog was often a problem and the low visibility caused many wrecks.

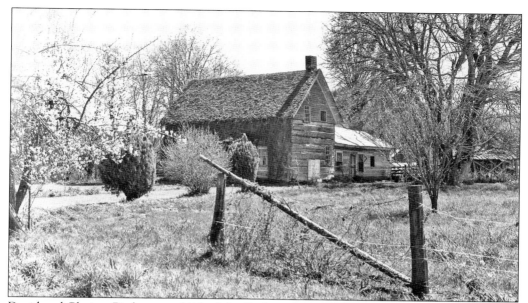

David and Clarissa Birdseye established the Birdseye farm in 1853. The main house was built in 1856. Pines trees were cut; then a broad axe was used to smooth them. Sam Steckel, owner of Steckels Mill, was hired to hew the logs and to dovetail them so they would fit together. Building this way made it unnecessary to use nails, which were hand-forged and very expensive.

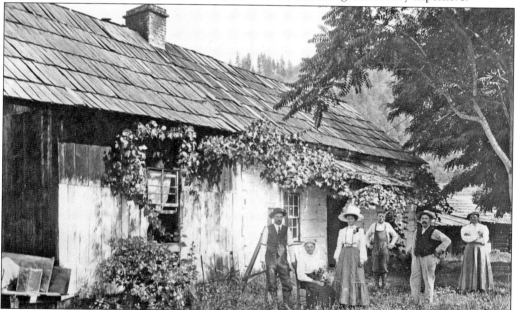

Located on the right fork of Foots Creek, this is the Mattis home. They lived there for over 40 years before selling to D. H. Ferry for dredging purposes. Shown are, from left to right, Albert Mattis; his mother, Amie Mattis; Anna Mattis; Susie Mattis; and two unidentified gentlemen. According to a 1930 local newspaper, "Miss Susie Mattis passed away at the home of her brother Albert in Rogue River on Thursday afternoon, December 4, after a lingering illness due to a fractured hip. She was 66 years of age."

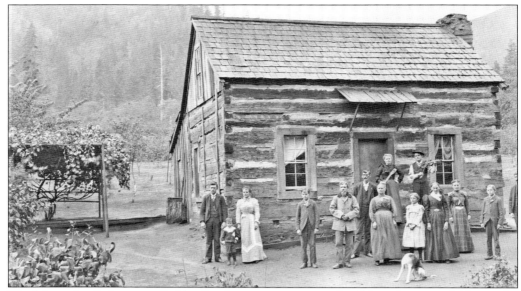

The Moore family home on Fielder Creek was a very neat and well-kept homestead. Notice the beautiful grape arbor at the left. From left to right on March 26, 1899, are Charlie Hatch, Arlie Hatch, Elizabeth Moore Hatch, Fred Witt, Nellie Witt Moore, Charlie Moore, Ray Moore, Mr. Moore, Etna Moore, Cary Moore, Grandma Kean (Etna's mother), Blanch Moore, Clint Moore, and Will Witt.

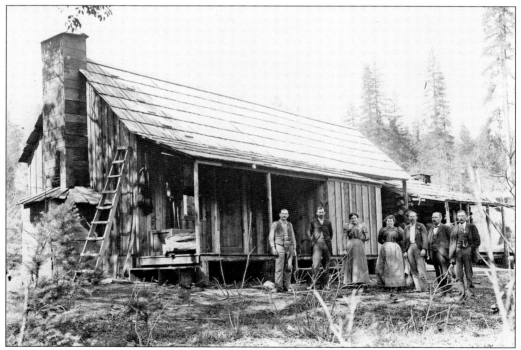

Taken by T. H. B. Taylor on March 19, 1899, this photograph features the home of the Jim Stevens family up Pleasant Creek. The back of the photograph says the fourth and fifth people from the left are Jim Calvert and his wife.

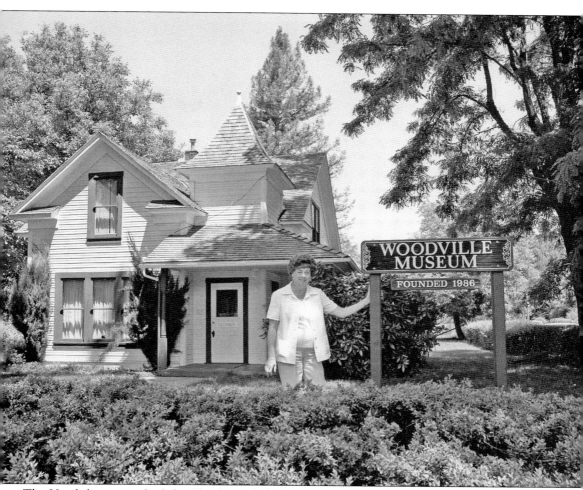

The Hatch home was built by Charles and Elizabeth Hatch in 1909 and served as their home until the 1950s. Charles and Elizabeth were married on March 26, 1894. (They can be seen in the photograph on the facing page with their son, Arlie.) In 1909, Charles was busy as a blacksmith in his shop on the corner of Main and Depot Streets. Every evening, he would put in long hours working on their home, which is believed to possibly be a Sears kit home. He had a lot of help from his friend Sam Mathis, who later became the first mayor of Woodville. The home was purchased by the Rogue River School District and used as a classroom for the band and choir before becoming the district offices. Later the home was the office for the local newspaper, the *River Press*. In 1986, the Woodville Museum group purchased it and, in May 1987, opened the Woodville Museum. Shown is Colista Moore, who was the driving force behind the founding of the museum.

Notice the interesting shape of the chimney on this home belonging to Hathaway Booker in 1890. It was located on Wards Creek, just outside of Rogue River. Shown is Hathaway Booker, seated, but the others are unidentified. Notice also the lace curtains, and imagine how proud the lady of the house must have been to own them.

This late-1960s photograph is of the Hilger house located at the corner of Broadway and Main Streets. It was a favorite place for neighbors to meet in the early part of the century because of the trees and a lovely garden out back.

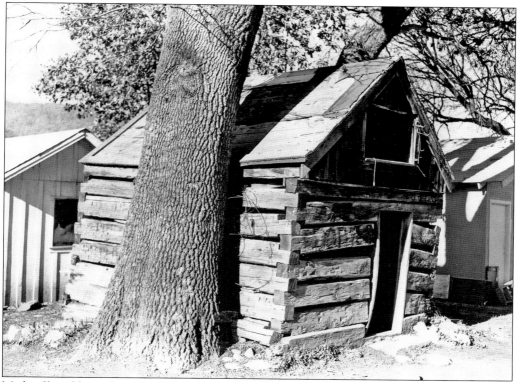

Made of hand-hewn logs, this building was originally used as a cold storehouse at the pear orchard owned by Walter and Nellie Jones. Walter was appropriately called "Pear" Jones, a nickname that stuck. The orchard was located on Main Street, on the southeast side of Wards Creek where the Rogue River Shopping Center is now located. They grew pears from the early 1920s, marketing them to the S.O.S. Packing House in Medford, until they sold the orchard in 1949. This historic cabin was saved and moved to Classic Park in Rogue River in 1976.

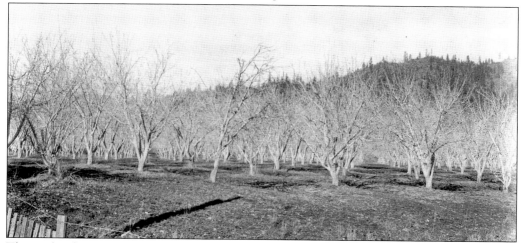

This orchard was located at the northeast corner of Evans Creek and Foothill Road where the Rogue River Middle School football field (Beck Field) is currently located. The prune and apple trees were a profitable business until they were taken out in 1913 or 1914.

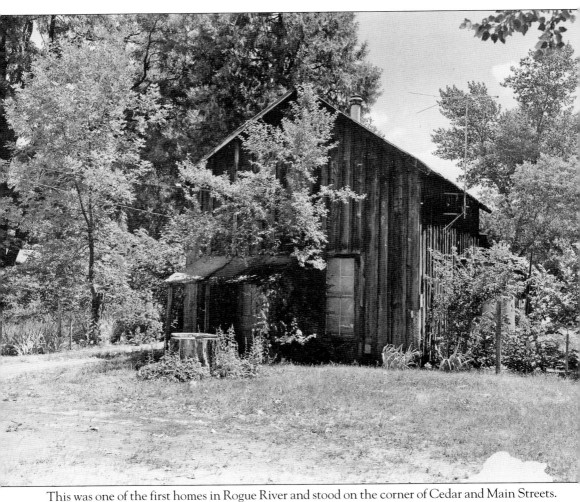

This was one of the first homes in Rogue River and stood on the corner of Cedar and Main Streets. Believed to have been built in the late 1800s by the Starr family, it was torn down in 1970. It was home to the Stiehl family in 1922 and was purchased by Harry and Hulda Skevington in 1936. Skevington was a town marshal for a while and later ran a quarry for Bristol Silica. The home was built of oak and fir that was mill sawn. Boards were placed vertically "because lumber was scarce and the house built that way to conserve lumber," said Skevington in a newspaper interview. He added, "With vertical construction not as many 2x4's or 2x6's were needed." If some of the boards were too short, they were simply patched at the bottom with shorter pieces. Clumps of violets and crocus would hide the patches. The Skevingtons never painted the house in order to retain the original appearance of the outside, which is why, on the day it was torn down, it still looked much as it did when it was built.

The camp cook is getting ready to fix up a good lunch of VanCamps Pork and Beans plus whatever game he has been able to bag that day. This photograph was taken in 1943.

Pictured in 1969, the Rooster Crow Queen rides on the back of a VW convertible, the car everyone wanted back then because of its good gas mileage.

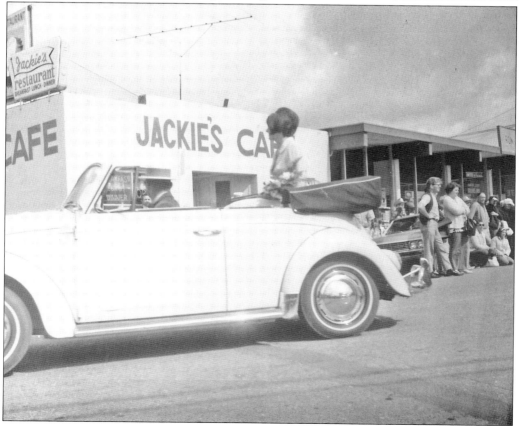

This is another example of T. H. B. Taylor's photography, taken in the late 1800s. It is the wedding picture of Bill Witt and Blanche Moore.

Three

OUR SCHOOLS

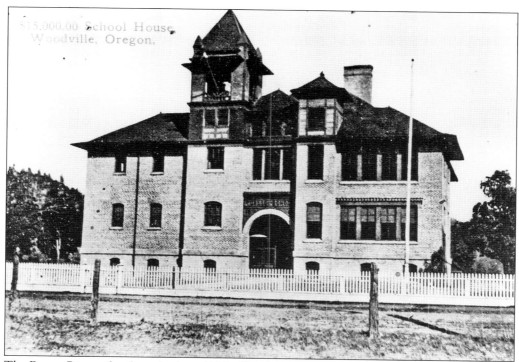

The Rogue River school was built in 1909 of bricks made at the Horton's Brick Yard. In January 1959, a fire marshal inspection declared it a "deathtrap." A public meeting was held to discuss the fate of the school. Emotions were running high as just weeks earlier in December 1958, three nuns and 92 children had died in a Chicago school fire. It was decided to demolish the old school.

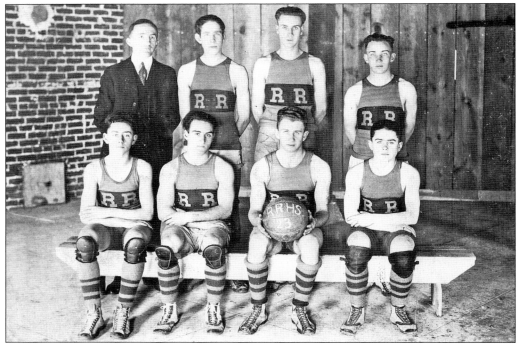

The members of the 1923 Rogue River High School basketball team are shown from left to right: (first row) Walter Wakeman, Victor Birdseye, Oroville Dingler, and Alva Laws; (second row) Prof. E. Brown, Cleland Banks, Elliot Butler, and Billie Moore.

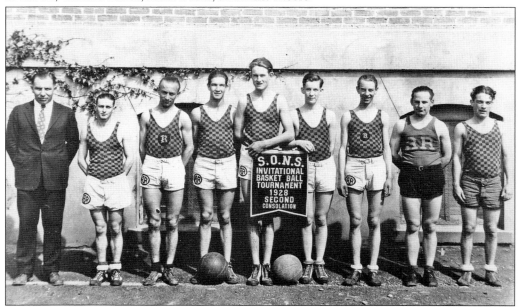

The Rogue River High School basketball team celebrated with a photograph after the S.O.N.S. Invitational Basket Ball Tournament in 1928. They came home with the second consolation prize. The team members are, from right to left, Leonard Kaup, Jewell Corey, Herman Wakeman, Roy Moore, Leland Harter, Burwell O'Kelly, Howard Wakeman, Harold Laws, and Clarence White.

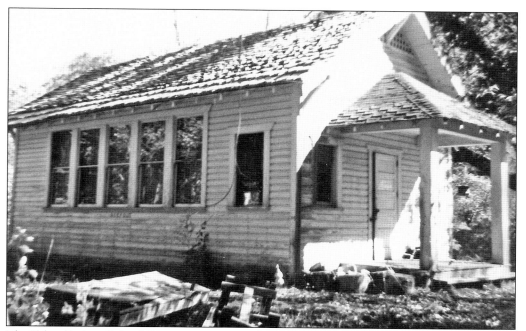

The Bybee Springs School District was organized in 1912, and the school building was constructed in 1913. It was named after the nearby mineral spring resort that was owned by William Bybee, one of the largest landowners in the county and former county sheriff. The building is now owned by Ken and Connie Hart and is in the process of being lovingly restored.

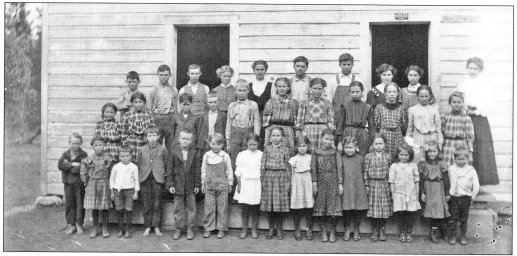

These students are standing in front of the Wimer School about 1905. From left to right are (first row) ? Moore, Lillie Neathamer, Charlie Moore, Burt Duston, Emil DeRoboam, Homer Owens, Lillie Oden, Lula Hocolmb, Alice Owens, Vera Oden, Gladys Moore, Lelah Hocolmb, Thelma Owens, unidentified, and ? Hocolmb; (second row) Eva Owens, Lottie Owens, Fred Neathamer, Earnest Oden, Fred Williams, Gladys McClellam, Lillian Owens, Hazel Moore, Olie Dustin, unidentified, and Edith Owens; (third row) ? Wistrom, Earl Oden, Nelsa Oden, Anna McClallam, Gertie Owings, Bill Williams, Jerry Owens, Jane Owens, Lucy Duston, and the teacher, Miss Sweny. Please note that all names are spelled exactly as found on the back of this photograph.

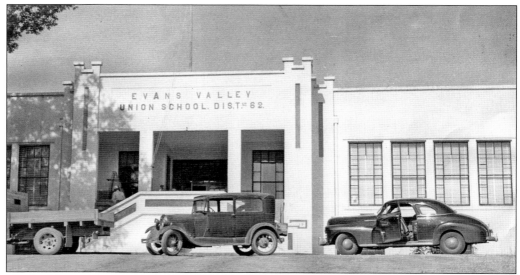

The building of Evans Valley School began in 1922 and was completed in 1923. It consolidated the five small Wimer schools: the first Wimer school, Mays Creek, Bybee Springs, Minthorn School, and Upper Pleasant Creek. Of these five original buildings, two are still standing and in use today: the Mays Creek School and the Bybee Springs School. John L. ("Jack") Weide was hired as the architect and engineer of the new Evans Valley School, and all the laborers were hired from within the community. The photograph below was taken in 2004, and it is easy to see how little the building has changed. It still sports its paint job of crisp white with royal-blue trim. For a short time in the 1980s, it was painted a yellowish-gold color, garnering much criticism from the community. It was soon restored to its original blue and white color. (Below, courtesy of Libby Miller Katsinis.)

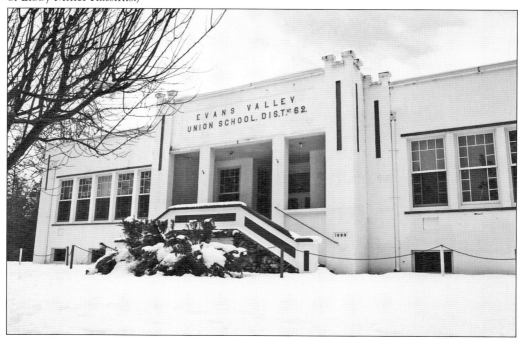

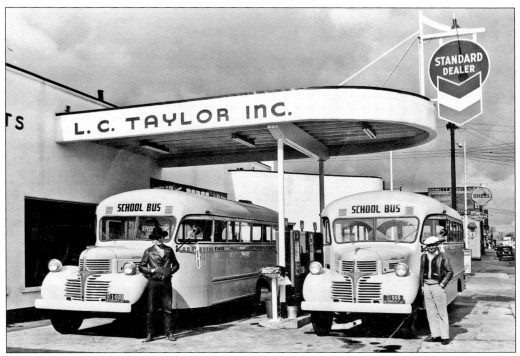

In 1939, James Martin (left) and Lee Hillis (right) went to Portland to bring home new Dodge buses for the Evans Valley School District. This photograph was taken in Portland. Notice the consecutive numbers on the license plates.

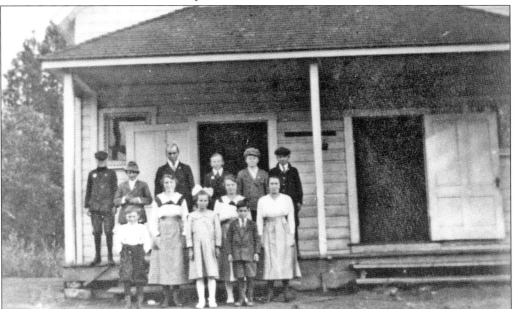

This is the old Pleasant Creek School. Only two students were identified on this photograph. Roy Moore is on the top right. Gladys Moore is on the bottom right. Roy Moore later married Colista Johnson Moore, who headed up the founding of the Woodville Museum.

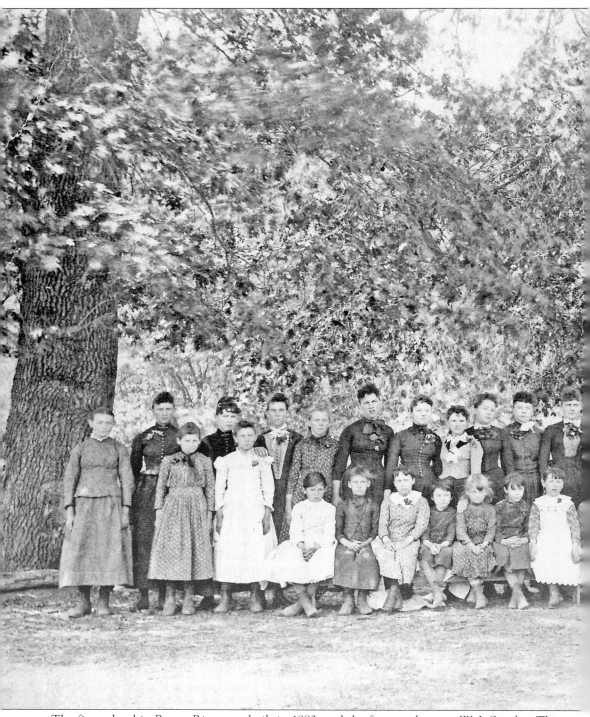

The first school in Rogue River was built in 1883, and the first teacher was W. J. Stanley. This photograph was taken in 1890 or 1891, and the teacher is E. E. Phipps. It was built of lumber

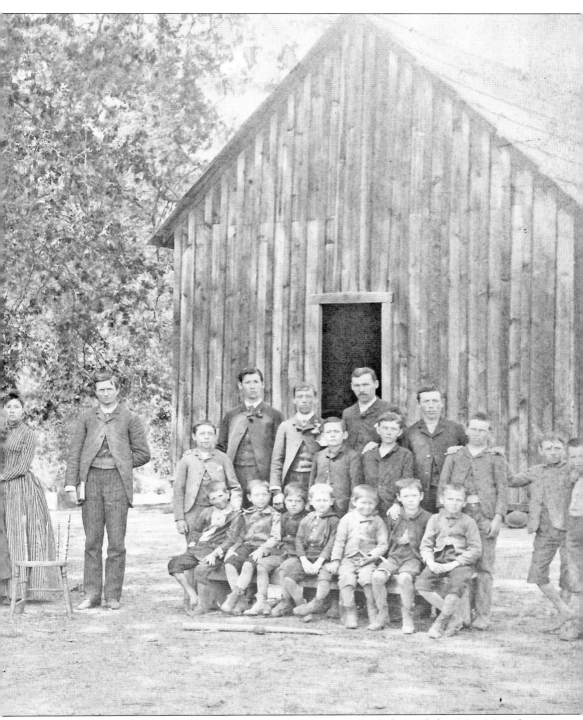

sawn by Sam Steckel. In his diary entry of November 16, 1882, Steckel noted that Mrs. Magerle, Baron Neathamer, and Ella Griffin came to him to "get up a school."

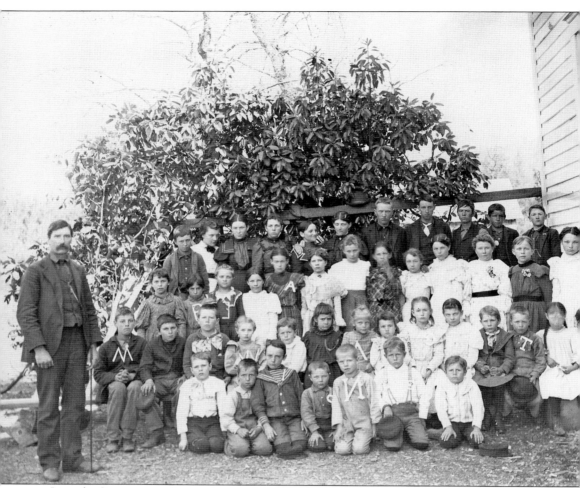

Lincoln Savage was the teacher at this two-story schoolhouse. He went on to become the superintendent of schools in Josephine County, and today there is a school there named after him. Historians are lucky to have a list of most of the students shown here. All names are spelled and listed exactly as written on the back of the photograph. From left to right are (first row) Andrew Bull, Willard Owings, Willie White, unidentified, Charles Hullen, Claude Burkhart, and Joe Burkhart; (second row) Ramond Stevens, Jeff Wimer, Willie Burkhart, Grace Hullen, John Bull, Myrtle Carter, Mary Hullen, Mary Jones, Pearl Smithline, Grace Stevens, Olie Bull, Charles White, Claire Wilcox, and Ada May Smithline; (third row) Minnie Train, Edna Carter, Coraline Wimer, Lizzie White, Carrie Smithline, Mary Bull, Roby Bedford, Nellie Magerle, Addie Jones, Anna White, Lula McCord, Myrtle Williams and Rose White; (fourth row) Jimmie Leslie, Grace Bedford, Maggie Smithline, Madge Owings, Abbie Griffin, Linney Stevens Connelly, Garfield Osburn, Henry Bedford, Al Smithline, Carlos Magerle, and Will Puyburn.

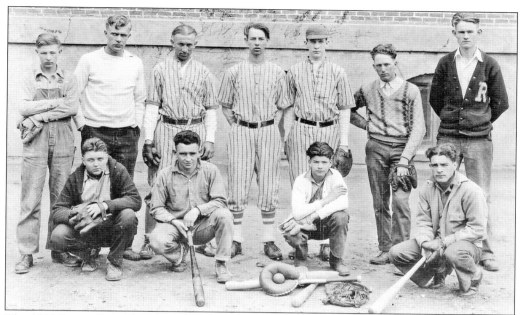

The 1930 Rogue River baseball team poses for a team photograph. From left to right are (first row) Hugh Hartman, Lee Gremmett, Cloud O'Kelly, and Charles White; (second row) Melvin Burnett, Merle Skow, Herman Wakeman, Howard Wakeman, Burwell O'Kelly, Earl Todd, and Leland Harter.

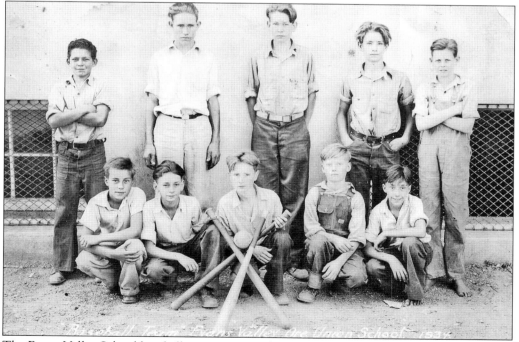

The Evans Valley School baseball team is pictured in 1934. From left to right are (first row) two unidentified, Kenny Williams, Stanley Lee, and Johnny Darland; (second row) Ike Orr, David VanHoy, Leo Butterfield, Pete VanHoy, and Beverly Humphrey.

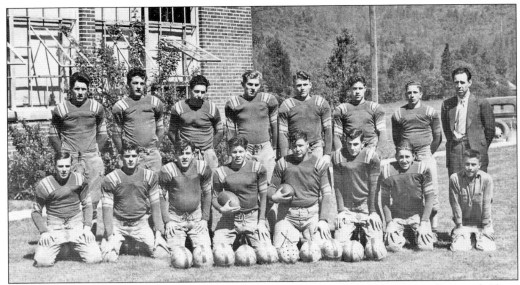

Pictured here is Rogue River High School's 1942 football team. From left to right are (first row) Claire Daggert, Kenneth Hatch, Dale Devine, Charles Moore, Calvin Osborne, Rusty Giesen, George Magerle, and Don Devine; (second row) Merle Randleman, Lester Stephens, Dick Skevington, John Stockman, Ralph Fitzgerald, Dale Hatch, Donald Dimick, and Kenneth Toner.

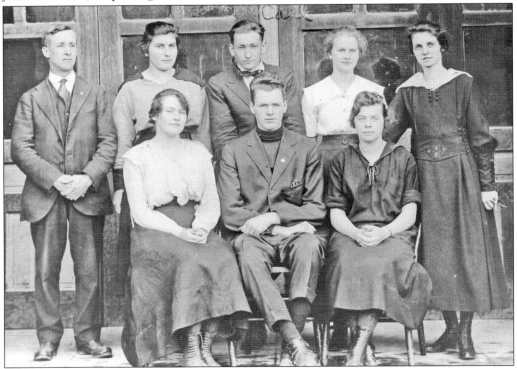

The Rogue River High School class of 1918 includes, from left to right, (first row) Alvira Steers, Rollin Taylor, and Lillie Martin; (second row) teacher B. G. Harding, Lottie Owens, Carl Magerle, Buelah Taylor, and teacher Alice Martin Streets.

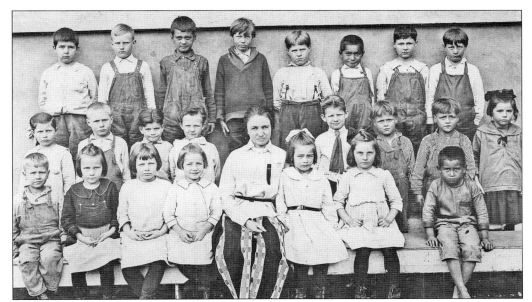

In 1920, the first grade in Rogue River boasted 23 students taught by a Miss Bradley. From left to right are (first row) George Ring, Dorothe Magerle, Oleta Rogers, Freda Laws, teacher ? Bradley, Audrey White, unidentified, and Darwin Patterson; (second row) Dolly Woodcock, Johnie Pickett, Cloud O'Kelly, Clarence Blakely, Gordon Hatch, Elsey Ring, Elsworth Ring, and unidentified; (third row) ? Wertz, Charles Champlain, Charles Patterson, Donald Blakely, Joel Dennis, Albert Patterson, William Wilson, and Roy Milton.

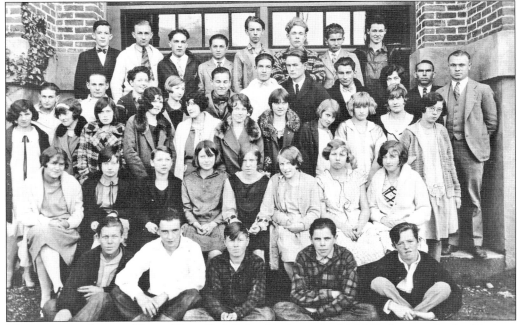

The entire population of Rogue River High School is shown in this 1928 photograph. At this time, classes were still being held in the old brick schoolhouse. In 1939, a separate high school building was constructed. It is still in use as a middle school, which houses sixth, seventh, and eighth grades.

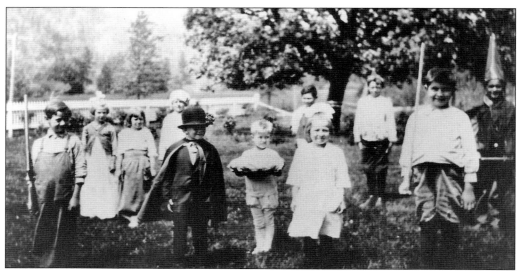

No one knows what this school play in 1921 was all about. Notice the dunce cap on the far right. Students shown are, from left to right, Roy Milton, Clarissa Fenton, Oleta Rogers, unidentified, William Wilson, Charles Patterson, Donald Blakely, Cloud O'Kelly, George Ring, Freda Laws, and ? Wertz.

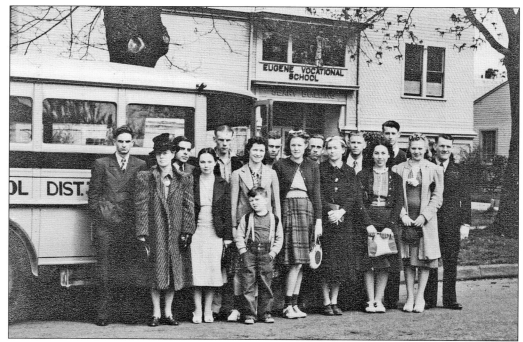

The graduating class of 1940 is shown on its annual senior class tour of public institutions. Here they are shown in front of the Eugene Vocational School. The child in front is Donald Dennis. From left to right are (first row) ? Dennis, Orva Jean Blackburn, Carol Turner, Wilma Shepard, Betty VanHoy, Wilda Mayfield, and Joan Thompton; (second row) Ed Griswold, Remington Bristow, Ernie Strahan, Tommy Burdett, Jack Galinat, Vernon Holm, Terry McDaniel, and Walter V. Dennis, superintendent of schools.

Four

Our Neighbors in Evans Valley and Wimer

The home of Fred and Harriet ("Hattie") Minthorn has been gone for years, but the name lives on in Evans Valley. There is a Minthorn Road, and until 1964, there was a covered bridge that bore the name. Former president Herbert Hoover was a nephew of the Minthorns and lived with them as a child. At one time, he gave a large collection of his books to the Rogue River Library in memory of his Aunt Hattie, who was a teacher and librarian.

In 1940 in Evans Valley, a team of horses patiently awaits loading of the hay wagon. On the wagon is James Martin with sons, from left to right, Jim, Fred, and Carl. Later the wagon has been filled and taken to the barn. It was hot sweaty work loading the hay and then unloading it again in the heat. (Both courtesy of Lawrence Martin.)

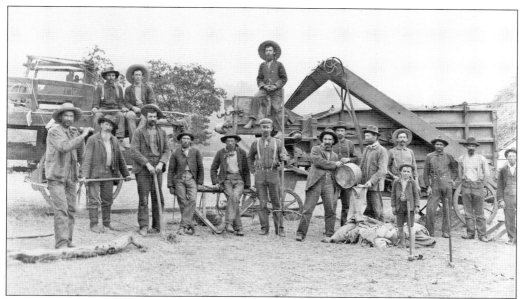

Threshing day was a big event on the local farms. The Savage family owned the thrashing equipment and would travel from farm to farm helping with the crops. This particular day was June 1, 1899, at the Jesse Neathamer farm on Evans Creek. The back of the above picture reads as follows: "On the wagon, Mark Burkhart and Dan Magerle; On the separator, Mr. Savage; Left to right: another Mr. Savage (possibly Morris), Steve Beers, unknown, unknown, George Magerle, Jesse Neathamer, Mr. Treffern, Al Davey, George Beers, VanGothen the Frenchman, Tom Oden with bushel measure, Fred Neathamer, boy." This picture was taken by T. H. B. Taylor. Other names listed on the photograph below include Dan Neathamer, John Neathamer, and Henry Crockson.

In Wimer in 1894, something fun is going on. Historians are not sure of the occasion, but it appears to be some sort of a play. Note the costumes, painted faces, and the piano on the right. Names as listed on the photograph are Frank Oden, John Hillis, Joe Wakeman, Doc Oden, Loris Oden, Will Hillis, Jim Oden, Miles Carter, Miles Wakeman, and Bert Oden.

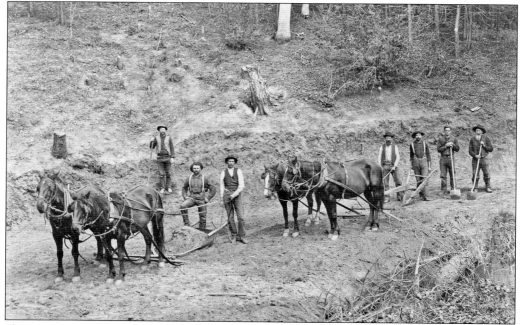

Shown are, from left to right, Al Davy, Tom Oden, ? Longfellow, George Beers, Steve Beers, Lloyd Beers, and unidentified. The men often got together to help each other with their farming, as "a load shared is a load divided."

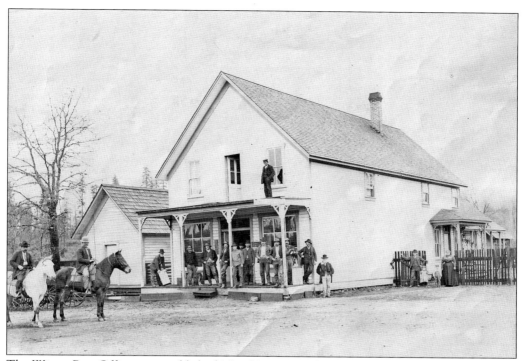

The Wimer Post Office was established May 23, 1887, and was located in a store about halfway between the current Evans Valley School and the Wimer Market on the right side of the road. It was a popular gathering spot. Shown here on June 1, 1899, are Mr. and Mrs. VanGothen and two children on the far right. Dick and Henry Oden are on their horses. Bill Carter, Jim Kady, and Norris Oden can be seen leaning against the posts on the left, Frank McCarval is on the right post, and Joe Whalen completes the crowd. Wimer was named after William Wimer, editor of the *Grants Pass* newspaper who wrote editorials backing the need for a post office in Evans Valley.

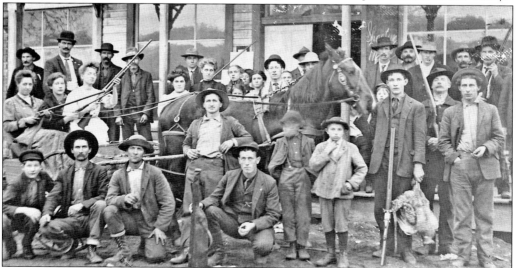

A turkey shoot in 1909 brought out plenty of the Oden, Hillis, Neathamer, Owings, and Moore clans.

Approximately 7.5 miles from Rogue River on East Evans Creek Road is the Martin home, settled in 1937 and known as the J<>L Ranch (the explanation is that J is for James, L is for Lottie, and the diamond binds them together in marriage). The year here is 1945, and the road has yet to be paved. Shown are James Martin and his five sons all on horseback. From left to right are Don and Lawrence, James, Jimmy, Fred, and Carl.

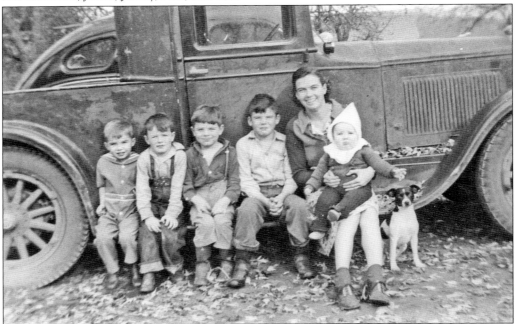

Lottie Martin is photographed here with five sons in 1940. Seated from left to right are Donald, Carl, Fred, Jimmy, and Lottie holding Lawrence. Two daughters would follow in the next 12 years for a total of seven children. James always said, "We raised kids and quarter horses on our ranch!" Just out of sight is the nice fat goose James had just shot for their Thanksgiving dinner.

In 1940, some of the schoolchildren play "London Bridge is Falling Down." In the front with their hands up are Phil and Patty Hillis with Jimmy Martin waiting to duck under.

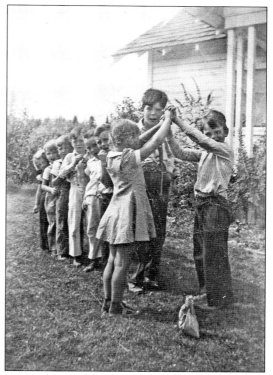

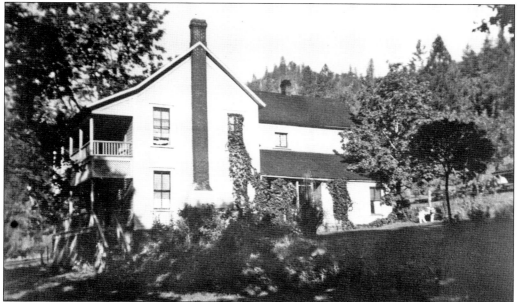

The Bybee Springs Hotel was built as a mineral springs resort and stage stop in 1892. William Bybee came to Jackson County, Oregon, in 1854. He and his wife, Elizabeth, raised 11 children. At one time, he was the largest landowner in Jackson County and also county sheriff. The Bybee Springs School was built across the street from the resort in 1913 and is still standing. The current owners of the hotel and old school are meticulously restoring both buildings.

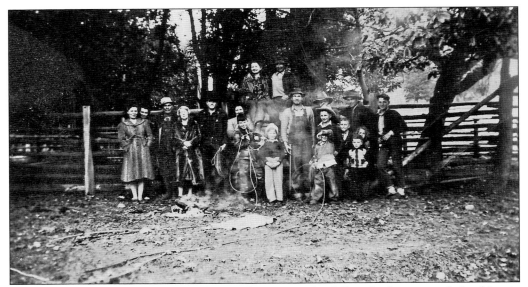

After a busy day of roping and branding at the Martin's J<>L Ranch, the women helped Lottie feed the crew by bringing potluck and then took time out to pose for a picture. The group includes some of the Neathamer, Hillis, Martin, and Austin families.

From left to right, Levi Oden, Ralph Oden, Paul Enos, and Lloyd Beers are pictured here in 1920 at the Pleasant Creek School. Something sure is making them laugh.

Bill and Jerusha (spelled Gerusha on some photographs) Moore, on left, were photographed with Jake and Rosa (Rosie?) Moore, on right, in 1917.

These beautiful c. 1918 calling cards were used by both men and women as the names on these attest. Here are the cards of Sabery Booker, John Brownsworth, Osee Oden, Teresa Winter, another for John Brownsworth, and Esther Oden. Delicate drawings that were brightly colored made them eye-catching.

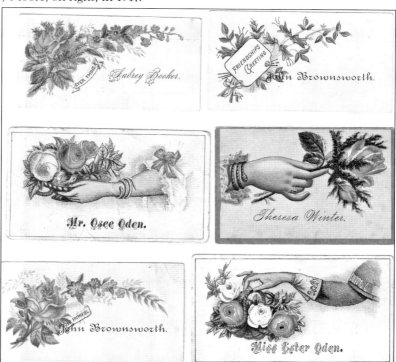

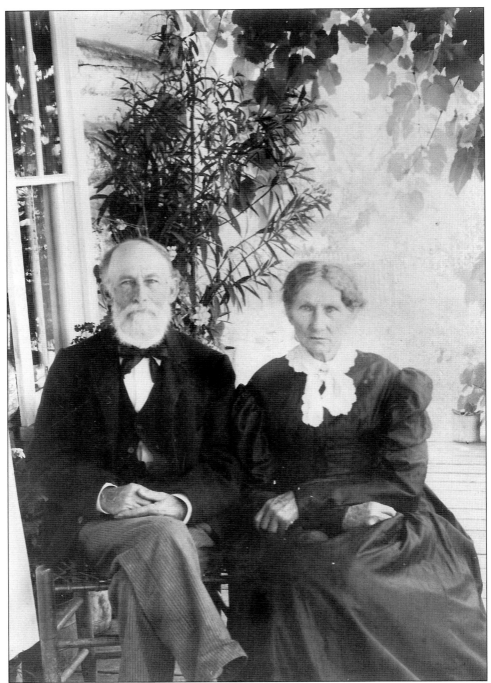

Miles and Sarah Wakeman of Pleasant Creek are pictured here. During the Native American uprising of 1852, Wakeman served in Company D of the 2nd Oregon Volunteers. He also fought for the union in the Civil War. Born in New York in 1829, he is found in Jacksonville, Oregon, in the 1870 census. On June 5, 1863, he married Sarah Evans, and they raised two sons. Miles Wakeman died in 1919 and is buried at the Woodville Cemetery in Rogue River.

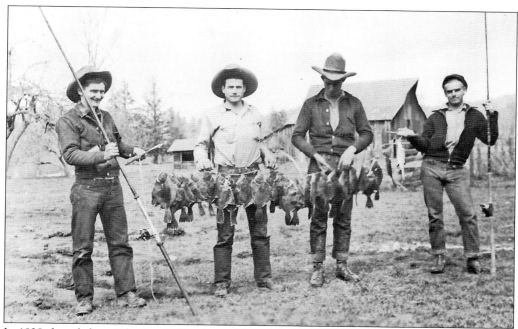

In 1938, from left to right, Lee Hillis, James Martin, Joe Soffel, and an unidentified man show off their catch of flounder. This good catch made it worth the trip to the coast.

Just past the Hillis place on Evans Creek above Wimer was a great swimming hole. Here some Wimer friends pose for a photograph after cooling off in the creek on a hot summer day in 1940.

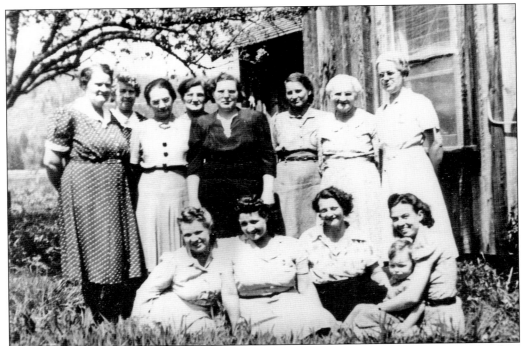

In 1941, the ladies of the Evans Valley Home Economics and Garden group met monthly. They often helped each other with canning, sewing, or cooking the huge meals required to feed a hungry hay crew. Here they are shown at the home of Gladys Wales, across from the Wimer Grange Hall. Much of the group is unidentified, but some names were found. From left to right are (first row, seated) Jane Williams, Betty Hillis, ? Talbot, and Lottie Martin holding son Lawrence; (second row, standing) Minnie Jensen, two unidentified, Sylvia Clark, Mrs. McCoy, and three unidentified.

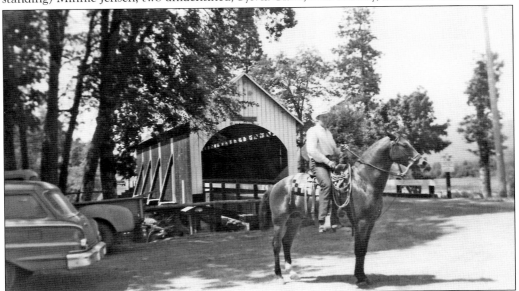

In the early 1960s, Wimer Market was a gathering place, whether by car, foot, or horseback. Delbert Lee is riding a horse belonging to James Martin, Candy Ace Martin.

Five

DIFFERENT VIEWS OF
ROGUE RIVER

This orchard was located at the northeast corner of Evans Creek and Foothill Road where Rogue River Middle School's football field (Beck Field) is currently located. The prune and apple trees were a profitable business until they were taken out in 1913 or 1914. The white building in the background was the school. Notice that it is two stories. The building was later reconstructed into the Presbyterian church. This photograph was taken in 1898.

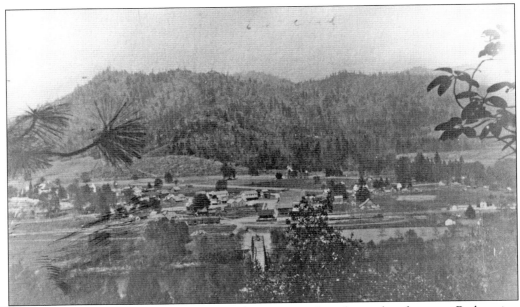

Aerial views are always a good way to see how an area has changed and grown. By locating the steel bridge in the lower center of these two photographs, one can see before and after the freeway was put in. The growth of homes has sprawled up closer to the foothills, and the town has enlarged. The above photograph was taken in 1912, the year the name changed from Woodville to Rogue River. The photograph below was taken in the 1960s, sometime after the freeway was built in 1962.

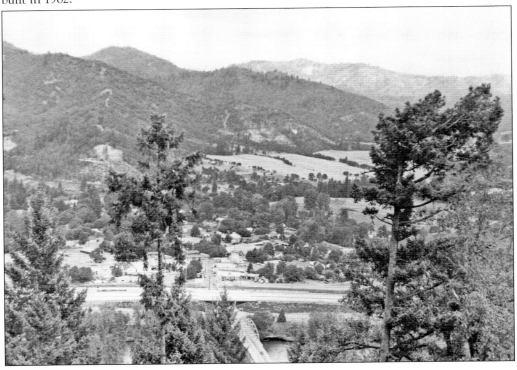

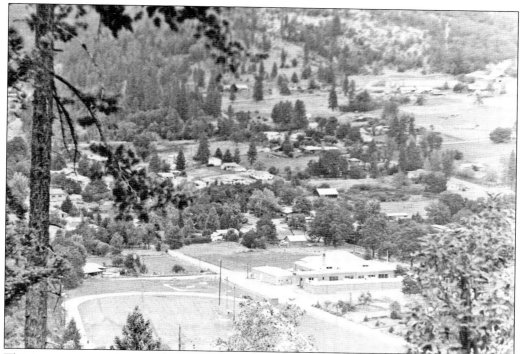

This is a great view showing the football field (Beck Field), where the apple and prune orchards used to be. This building was constructed as Rogue River High School in 1939 and is now the middle school, housing sixth, seventh, and eighth grades.

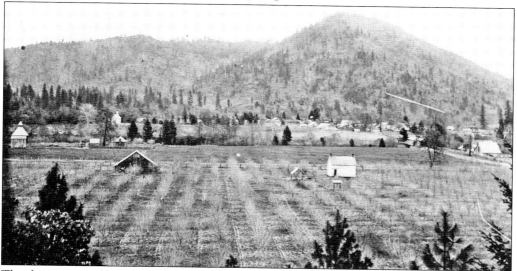

This farm was on the northwest corner of Evans Creek and Foothill Road. The house is believed to have possibly been a Sears kit home but was not documented before it was demolished in 2008. The fields directly across the road from the house, between the road and Evans Creek, were strawberry fields at one time and provided a source of employment for many local children in the summers. The white building across the fields was the original schoolhouse that was remodeled into the Presbyterian church.

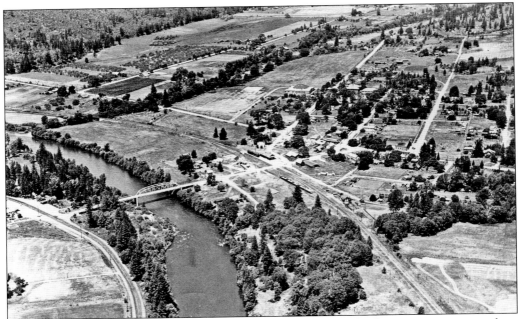

In these two similar aerial photographs, both taken from the south of town, it is easy to see how the advent of the freeway changed the town of Rogue River. People used to cross the large steel bridge (just out of sight on the far left of the photograph below) and drive on Rogue River Highway north to Grants Pass or south to Medford. There were numerous small "mom and pop" businesses that thrived until the opening of Interstate-5. After that, people could speed past the small towns and head for the larger cities and better prices. At the same time small businesses were struggling, the freeway made it easier for people in the larger towns of Grants Pass and Medford to move to "the country," and Rogue River became a bedroom community. Houses and subdivisions began springing up and the population grew.

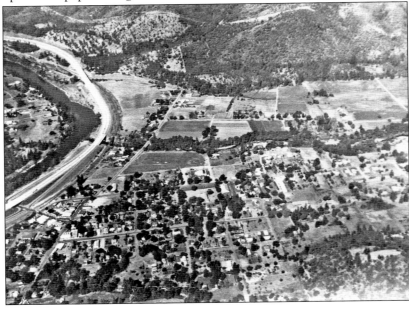

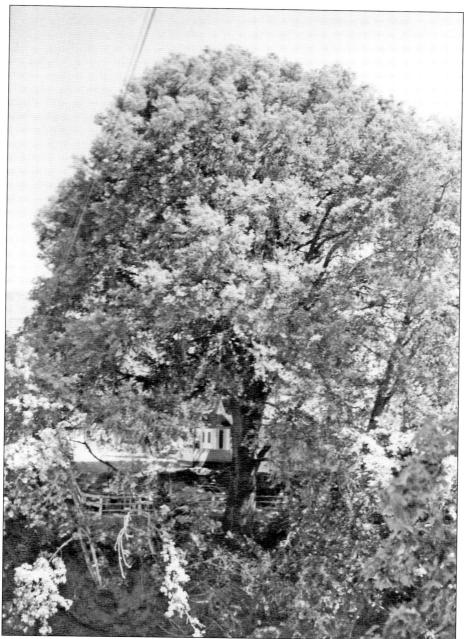

Rogue River is a certified "Tree City" because of its many trees, both old and new. This live oak tree was located on the banks of Evans Creek where it empties into the Rogue River and was there in the original days of the town. In 1905, it was so large that members of the Lewis and Clark Exposition (a forerunner of the World's Fair) wanted to cut it down to display it at the exposition in Portland. The people of Rogue River joined together to fight the removal of the tree and vowed to boycott the exposition if the tree was cut down. They succeeded, and the tree lived for nearly 100 more years. It was said to be the largest live oak in Oregon, and when measured in the 1970s, it still held that distinction.

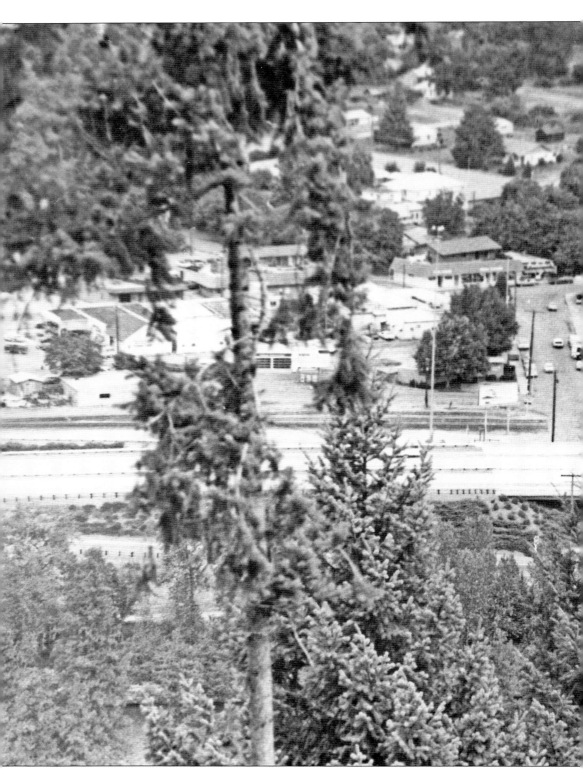

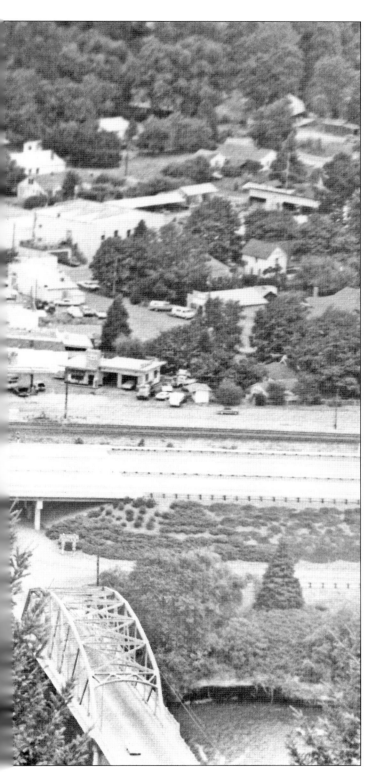

The late 1960s found Rogue River still an innocent town, untouched by much of the drug culture that was invading other areas. Kids still worked picking strawberries at the farm on West Evans Creek Road and had bonfires to celebrate homecoming at the high school. This photograph was taken from a hill on the south side of the river, above Gail's Market. The freeway was still very new and seemed so modern. Reactions to its presence were mixed.

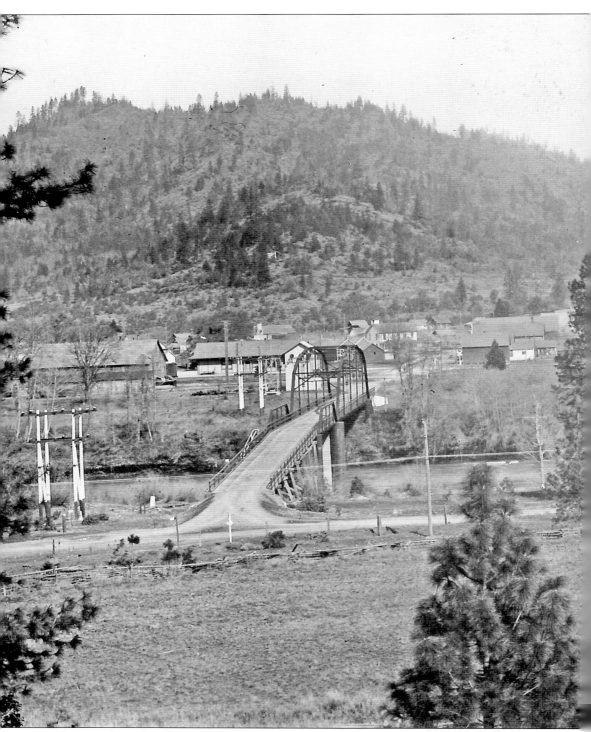

The view from this photograph is similar to the one on the previous page and was also taken from the hill on the south side of the river above Gail's Market. It was taken before 1909 and

ROGUE RIVER OR.

can be dated by the old bridge.

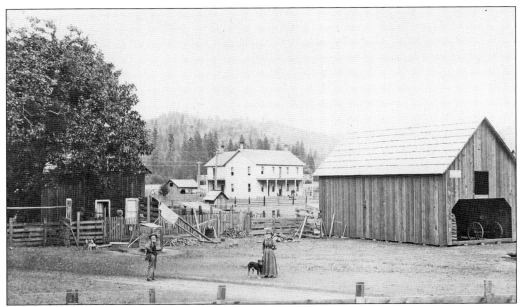

John Woods and Mattie Seaman are photographed here in the late 1800s. John Woods was the man Woodville was named after. Mattie Seaman was a widow who had two daughters. She supported them by nursing and midwifery. The white building in the background is the Wilcox Hotel, built in the mid-1890s.

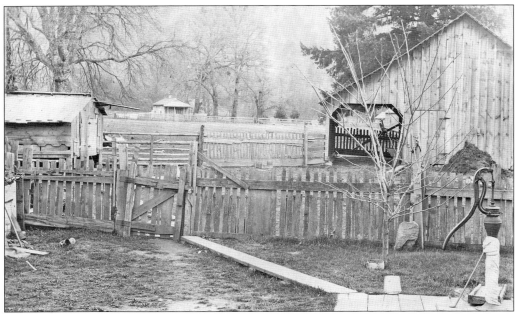

Here is a typical town of Woodville yard. Note the beautiful hand water pump at the far right of the photograph.

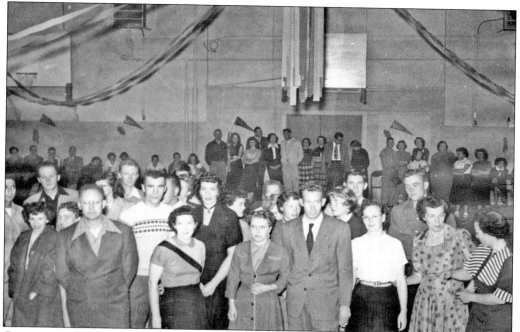

Community dances were often held in the elementary school gymnasium. This particular one was in 1946. Shown from left to right are Donald Dimick (who is still known as "Junior"), Chatty Hilger, Rita Jennings, Florence Neathamer, Orvis Reeter, Carolyn Gelvin, Neil Moore, Rusty Geisen (whose given name was Parnell), Mary Smith Reeter, Jennie Bunce Giesen, Jeannie Sauer Branam, Bud VanHoy, Avis Osborne VanHoy, Myrtle McLaren Stockton, and Alyce McLaren Archer.

The Rogue River Assembly of God church was built on this site on Broadway Street in 1952. When it moved to a new location on West Evans Creek Road in the late 1970s, Bob Kirkwood bought the building and turned into a store.

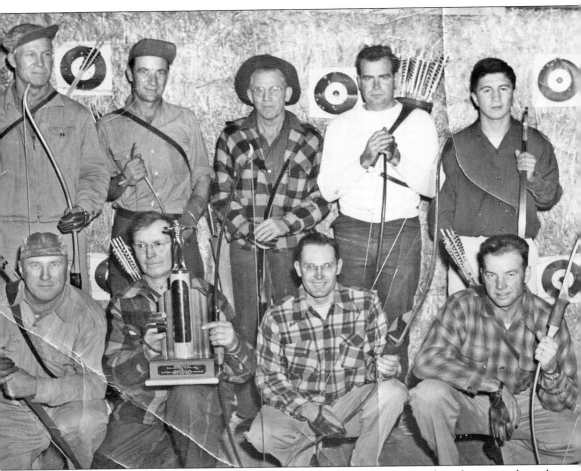

In 1955, the Rogue River Archery Club must have had some pretty good marksmen, judging by the trophy. From left to right are (first row) William Peters, Claude Hilger, Ralph Smith, and Woody Frantz; (second row) Mac McKenzie, Hurst Morgan, Glenn Nourse, Ray Frantz, and Sam Black.

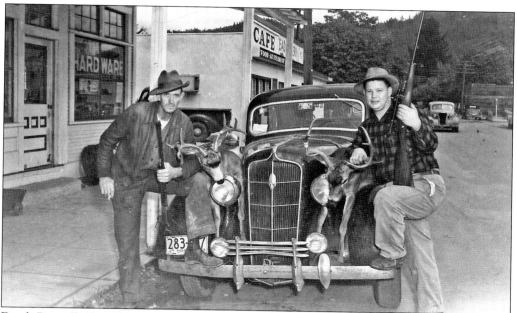

Frank Bean (left) and Calvin Osborne (right) had a successful hunting trip. They are shown here each with a deer and some nice-looking rifles. The tags in the center of the car window say 1945. Osborne had the unfortunate nickname of "Blimp" that stuck with him for a lifetime. He was plagued by heart problems and died at a young age while on a hiking trip with friends in a wilderness area.

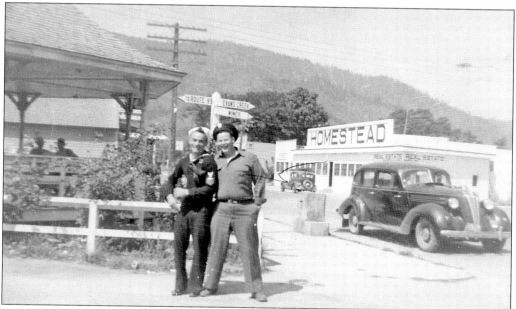

Richard McLaren (left) was happy to be home on leave from the navy. He and friend Calvin "Blimp" Osborne (right) share a laugh near the bandstand in 1943 or 1944. Richard was born in 1923 in Burns, Oregon, but his family moved to Rogue River shortly after his birth. He is still living in the Rogue River area.

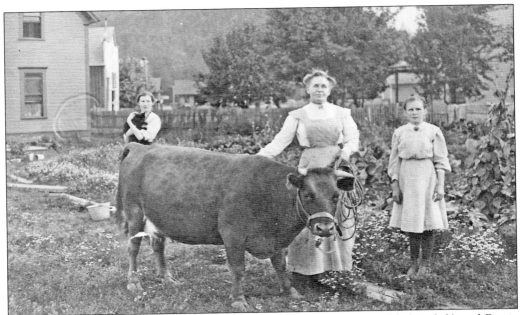

Mattie Seaman is shown here with her daughters Blanche (above and below, left) and Bessie (above and below, right). They lived on Main Street next to the Wilcox Hotel, and Mattie was a highly respected figure in the community. All who knew her, whether related or not, lovingly called her "Aunt Mattie." She was the widow of a stagecoach driver who supported her daughters by practical nursing and midwifery. She kept a beautiful garden, chickens, and a milk cow so that she always had nourishing food for the mothers who came to her home to deliver their babies. She also had bathtubs and running water installed for their convenience. Doctors came from Grants Pass by horseback or buggy to attend to the patients.

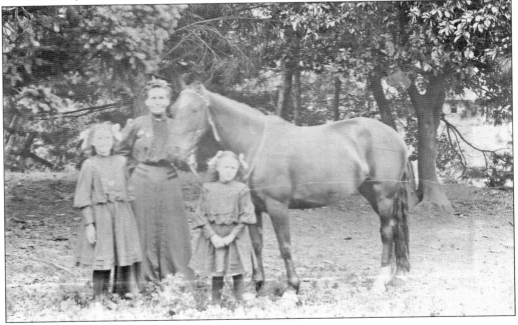

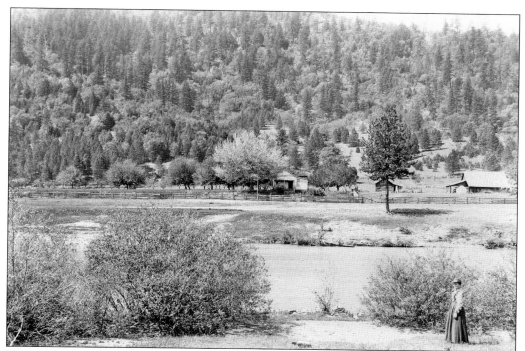

The Mathews place in the late 1800s was located on the west side of the river near the Birdseye home. In 1936, this was the George Martin place.

This is a different view of the Wilcox Hotel, at the corner of Oak and Main Streets, and shows the addition that was put on the back. It was first built in the 1890s as the Wilcox Hotel and changed to the Woodville Hotel, then the Pioneer. It was finally torn down in the 1940s. Shown here is Frank Clements in the white shirt and Melvin Whipple by the post. Mattie Seaman's house is in the background.

In 1953, merchants wanted to promote their city. Shade Combes read about miners in Wales who had a rooster crowing contest. They agreed this might be just the thing to call attention to their town and pledged $100 in prizes. First prize of $50 went to Hollerin' Harry, owned by 16-year-old Donnie Martin. His rooster crowed 71 crows in 30 minutes. The event is still held the last Saturday of June.

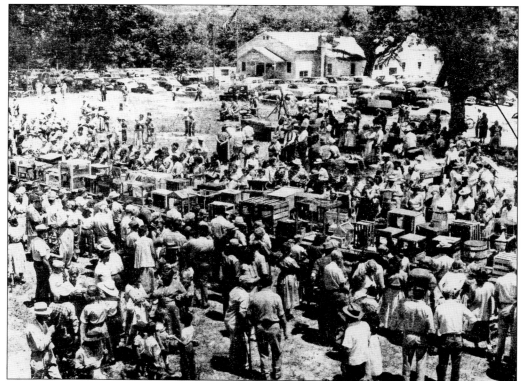

Though this is not a good picture of the Rooster Crow, it does show the VFW Hall in the background and is one of the only photographs of it that could be located. Like the grange hall, it was built from an old Camp White building.

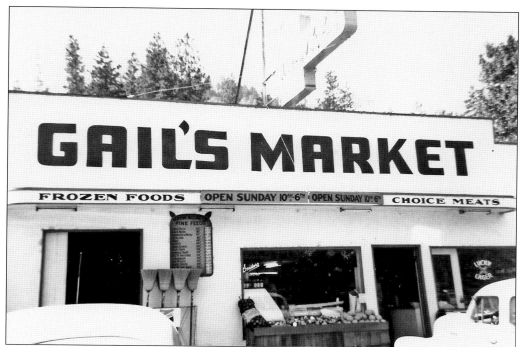

Gail's Market was located across the bridge on the south side of the river and was built in 1945 by Bob Gail. After being flooded in 1955, Gail rebuilt and operated his store in the same place until 1963, when he built a new store at the back of the lot on a higher elevation. The new store building flooded in the 1964 flood. He cleaned up once again, remodeled, and continued operating the market until 1975, when he sold it.

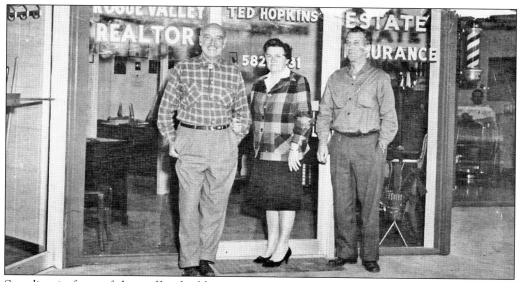

Standing in front of their office building next to Kirby's Restaurant, just to the south of Gail's Market, are, from left to right, "Colonel" Ted Hopkins, Beth Hopkins, and Pitt Penny. Always known as Colonel, Hopkins was a real estate agent.

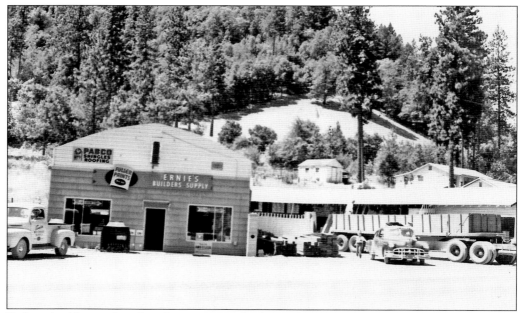

Before the Nugget Lumber Company was built on this site in 1976, there had been several different businesses here, including the Bridge Café in 1933, Rogue All-Around Gardens in 1944, Winfield Electric in 1945, and Lugenbeel Tire Shop in 1946. It was operating as a garage when it was demolished in the 1964 flood. Harry Nugent bought the property and built the lumber company, which became Ernie's Building Supply. The Truman Drew Furniture Company also operated out of a building on this site. In 1989, Bill Woodhead bought the property. In 1991, he opened Inn at the Rogue, a Best Western Hotel.

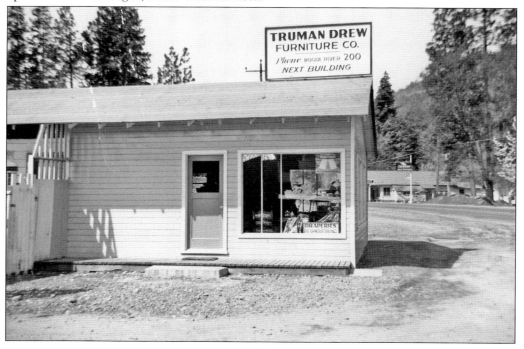

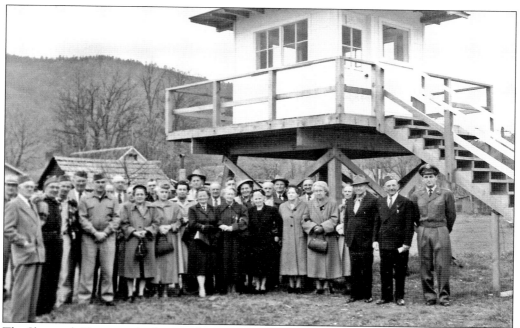

The Skywatch Tower was built around 1940 in response to World War II. According to a newspaper clipping, it was "constructed rapidly by the Lions Club with the cooperation of the city, the lumber mills and individuals." Volunteers manned the tower. Some shown here are Carl Christianson, Larry Sheehan, Pete Petrie, Frank Hall, Stella Miller, Lloyd Smith, Edna Sheehan, Midge Petrie, Mattie Smith, Maude Dingler, Leslie Trotter, Hulda Skevington (on right with purse), Elizabeth Fowler, Fred Dingler, and Howard Miller.

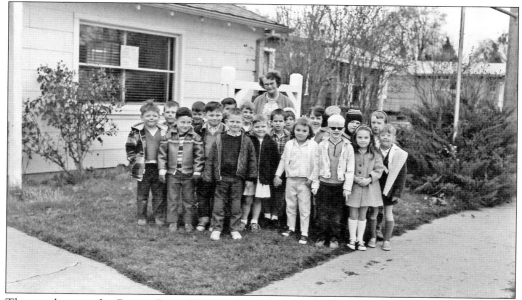

The teachers at the Rogue River Elementary School would often walk their students the few blocks into town for field trips to the library or city hall. In 1967, the first-grade class of Arlene Goodrich walked to city hall for such a trip.

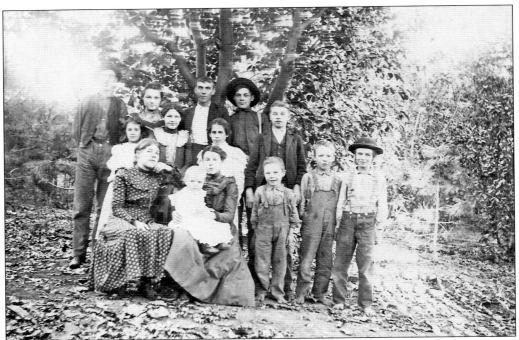

In 1905, members of the Breeding, White, and Carter families pose for a portrait: (first row) Nell Carter, Ann ? holding Edwin Haymond, Bill White, Charlie White, and Bob Breeding; (second row) Myrt Carter, Lizzie White, and Edna Carter; (third row) Slim Breeding, Rose White, John Breeding, Todd Carter, and Jim Breeding.

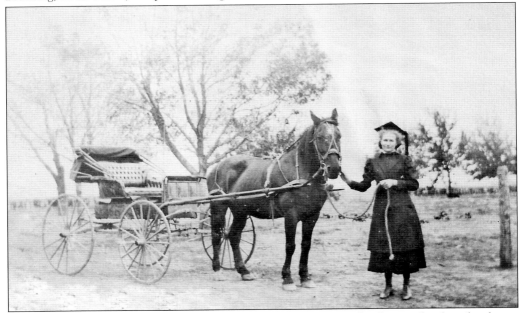

Muriel (Mathews) Hawkes used to drive her horse and buggy to school every day from her home on Foots Creek, approximately 5 miles. Later she was a fifth- and sixth-grade teacher in Rogue River in 1927 and 1928.

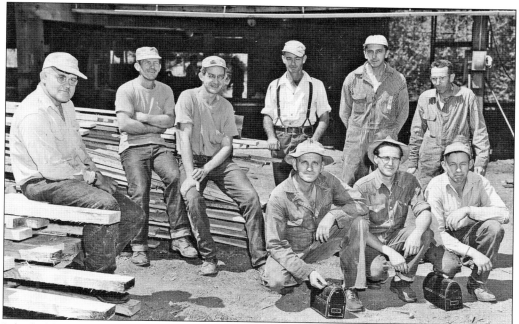

It looks like it is lunchtime for these gentlemen at the Galls Creek Mill. Shown from left to right are (first row) Frances Adams, Ralph Smith, and Louis Wagner; (second row) Ernie Woodcock, Sid Strahan, Bill Purrier, Edsel White, Glenn Miller, and Don Moon.

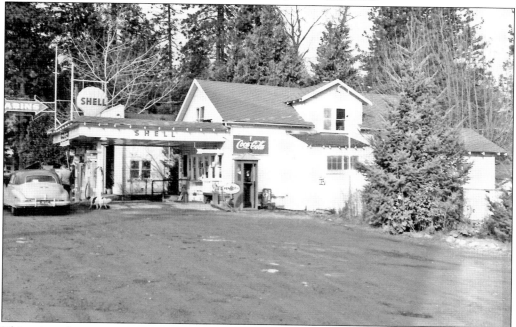

This crisp white service station was located on the southwest side of the bridge and was known as Ed Lilly's Shell Station. Directly across the street was another building that looked very similar to this one. It was a Texaco station and the Bridge Café. Many of these early businesses on the south side of the bridge were lost or severely damaged in the various floods.

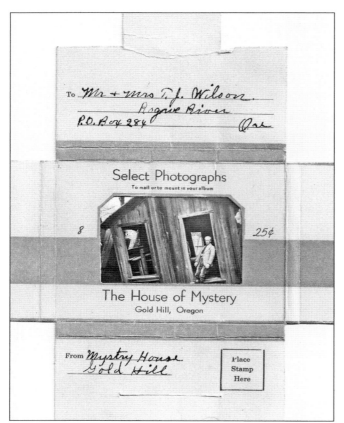

To Mr + Mrs T.J. Wilson.
Rogue River
P.O. Box 284 Cal

Select Photographs
To mail or to mount in your album

8 25¢

The House of Mystery
Gold Hill, Oregon

From Mystery House
Gold Hill

Place
Stamp
Here

The local Native Americans knew the area around the Oregon Vortex as "Forbidden Ground" because their horses refused to go into the area. The House of Mystery itself was originally an assay office built by the Grey Eagle Mining Company in 1904 and later used as a tool shed. John Litster was a mining engineer, geologist, and physicist who did thousands of experiments there. Vortex means a whirlpool of force, and this force causes strange phenomenon to occur, such as objects rolling uphill and people appearing to be different heights in different areas of the vortex. He developed the area and opened it to the public in 1930. Even in the 1930s, it was a popular tourist spot, and these packets of photographs could be purchased as souvenirs. The Oregon Vortex and House of Mystery are still in operation today.

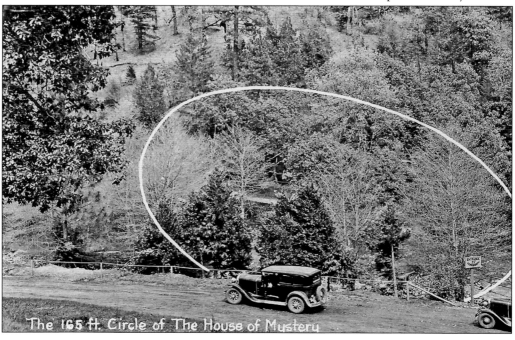

The 165 ft. Circle of The House of Mystery

The Wolf Creek Inn is another historic close neighbor of Rogue River and was on the line of stage stops that included Woodville. It has the distinction of being the oldest continuously used hotel in the state of Oregon. When pioneer Henry Smith built the inn in 1883, it was billed as a first-class hotel for folks traveling by stagecoach. It was originally called the Wolf Creek Tavern, which described a hotel that served food. Henry Smith planted much of his land into orchards, many of which still stand today. The hotel is still in operation, and apple and pear trees that grace the property were planted in 1885.

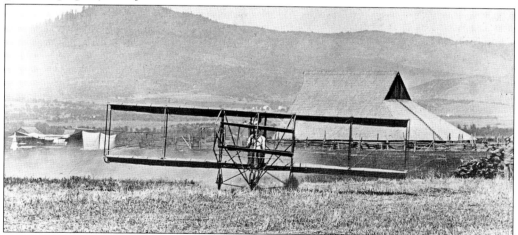

On June 4 and 5, 1910, the first Aviation Meet was held in southern Oregon, featuring flyer Eugene Ely. Just five months later, on November 14, 1910, Ely had the distinction of being the first aviator to make a landing on a special platform built on the deck of a ship, the USS *Birmingham*. Until just recently, the barn in this photograph was still standing close to where the Medford International Airport is now located. Rodeos used to also be held there.

The little town of Leland was a close neighbor of Rogue River and Wimer. The miners who worked the creeks of Evans Valley would often travel over the hill to the Leland store, as it was closer than going to Woodville. Though several people are shown in this photograph, the notation on the back simply says, "Will Fallen, Leland store."

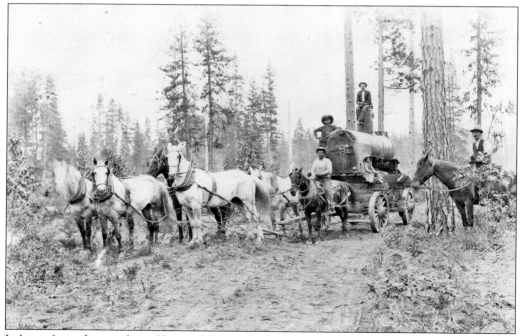

Judging from the number of horses hitched to this wagon, the load must have been heavy. It appears to be a furnace they are hauling to Leland, and perched atop the load is Harry Taylor. The year was 1899.

Six

Old-Time Logging

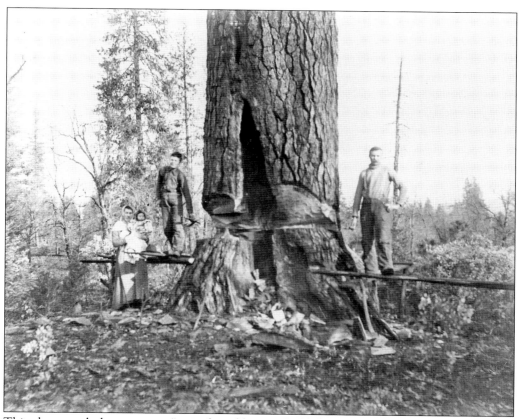

This photograph demonstrates "springboard logging," which was the practice of cutting a notch in each side of the tree and inserting a board to stand on. Two men could take down a large tree in fairly short time using this method of logging. Shown are, from left to right, Florence Taylor holding baby Rollin Taylor, George Gordon, and Harry Taylor in 1898.

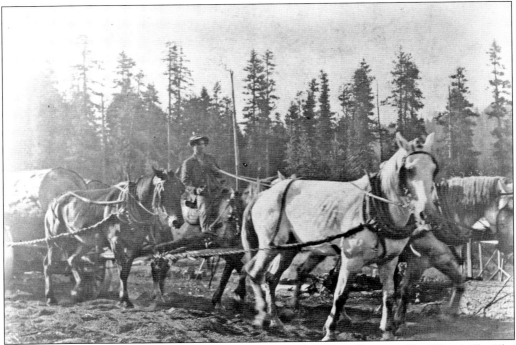

Once the logs were cut, teams of mules and horses hauled them to the sawmill at Woodville. The year is approximately 1909.

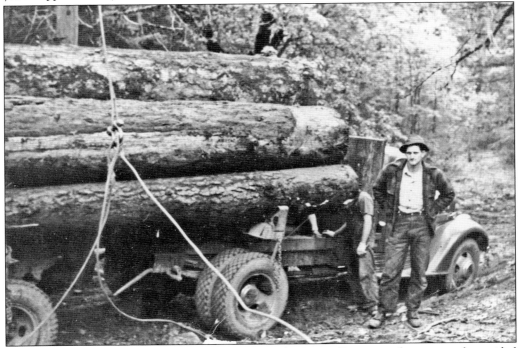

Elmer Milton ran a successful logging company in the Rogue River area for years and provided a source of employment for many men.

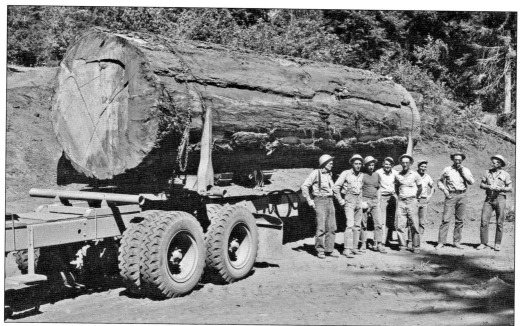

It only took one tree to fill this log truck in 1959. Shown here on a smoke break are, from left to right, Red Morris, Earl Puritan, Phil Hillis, Nate Banry, Pete McFall, Elmer Baker, Roy Milton, and Delbert Lee.

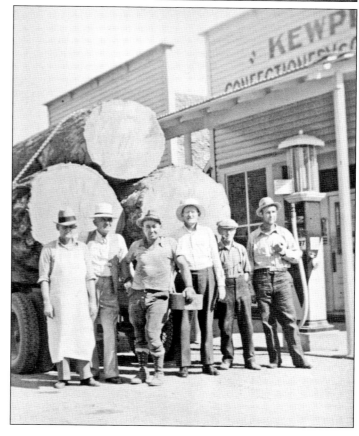

Look at the size of those logs. Standing from left to right are Charlie Totten, Harry Hill, Bud Shults, Ward Will, Johnny Winders, and Boyd McClung. The men are standing on Main Street, Rogue River, in front of Kewpies Confectioners, and the year is sometime in the 1940s.

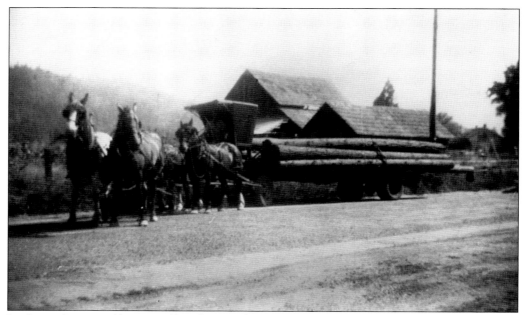

Joe Jensen's team of horses pulling logs to the sawmill was a common site in the Wimer area. Even in the 1950s, he still used the horses and wagon.

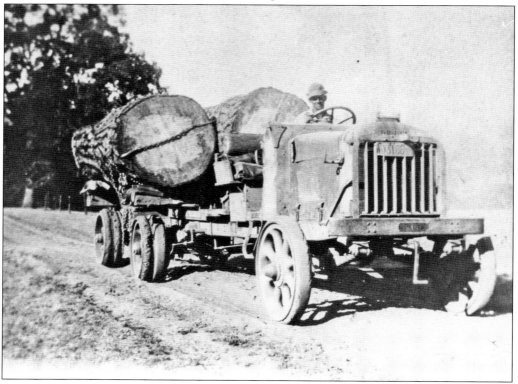

In the 1920s, using a truck to haul logs was considered very modern. Notice the ragged wheels on this truck and imagine the bumpy ride.

Seven

EARLY MINING

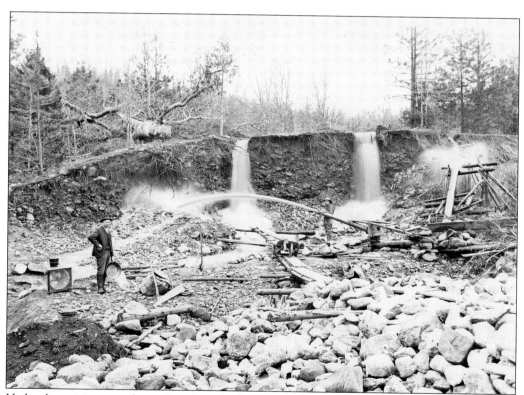

Hydraulic mining was the preferred method of mining because the miners could move massive amounts of earth in a short time. Shown here in 1898, Harry Taylor is on the left while an unidentified man holds the high-pressure water hose. They are at the Lewis Mine located on Graves Creek.

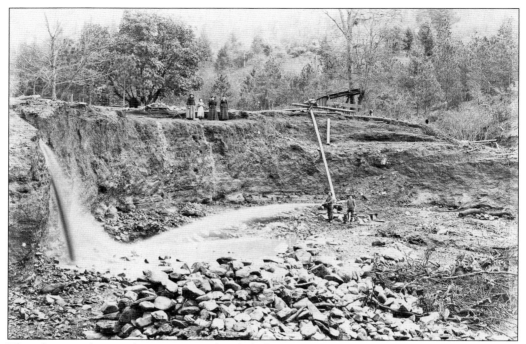

This photograph was taken sometime shortly before 1900. Jeff Wimer Sr. is shown operating the high-pressure water hose, called a giant, while his son Jeff Wimer looks on. Observing from atop the bank are, from left to right, Georgia Wimer, Carlie Wimer, Sabery Booker, and Florence Taylor. Georgia, Sabery, and Florence are sisters, and Carlie is the daughter of Georgia.

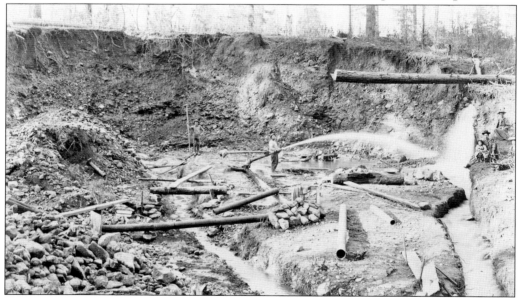

In 1899 in Wimer, the Moores and Odens shared mining duties at this mine on Pleasant Creek. W. D. Moore is shown piping, assisted by Dick Oden. From left to right, Mabel Owings, Jerusha Moore, Hazel Moore, and Rose Moore are watching from the right side of the photograph, accompanied by Skip the dog.

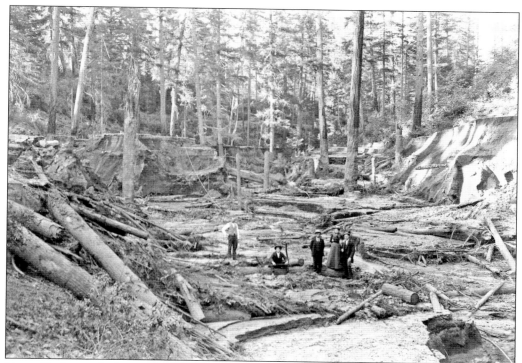

Harry Taylor worked mines on several creeks, and he is shown again at a mine near Leland. Taylor is the one on the left in shirtsleeves. The others are unidentified. This type of mining was very hard on the environment and left huge scars on the landscape. Evidence of the mining can still be found today. All of the creeks in the valley have huge piles of rocks beside them called mine tailings.

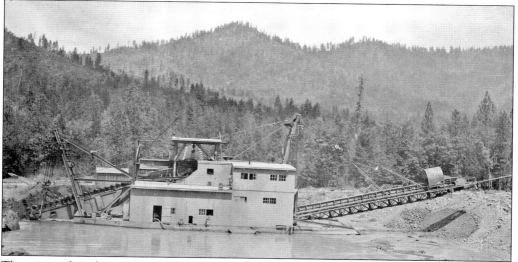

This piece of machinery was called a gold dredge. This one was located on the Rogue River, but there was also a similar one on Pleasant Creek in Evans Valley. After sitting quiet for years, it was dismantled in the 1990s and shipped to Canada. The piles of mine tailings around it are still in evidence.

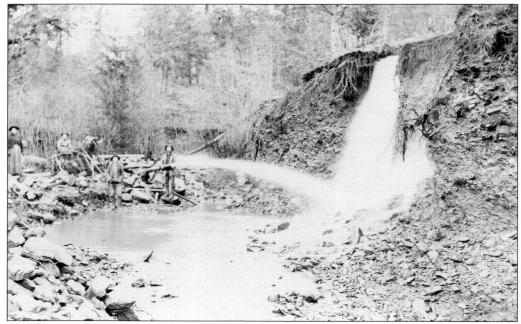

Again in 1899, the Wimer family is busy mining. Georgia Wimer is on the left accompanied by Carlie Wimer, Jeff Wimer, and Jeff Wimer Sr. Notice how much water is used and the huge amounts of dirt that are removed.

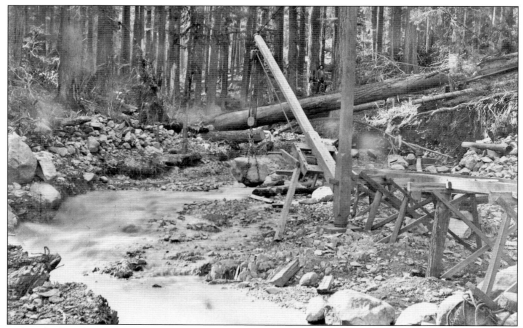

When hydraulic mining was done on Foots Creek, between Rogue River and Gold Hill, a hoist with chains was rigged up to move the large rocks. Today along Foots Creek Road, there are huge piles of these rocks, called mine tailings. They are covered with moss now and are a beautiful reminder of the not-so-beautiful practice of hydraulic mining.

Eight

DAMS AND BRIDGES

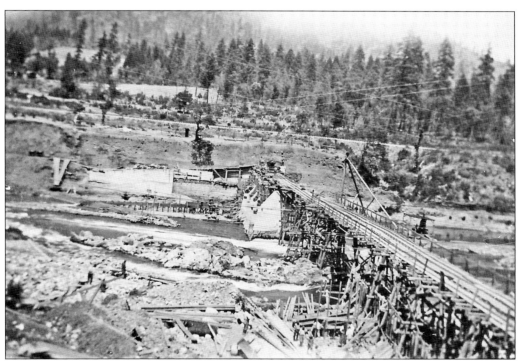

Located on Highway 99 (locals call it "the old road") between Rogue River and Grants Pass is Savage Rapids Dam. The Grants Pass Irrigation District was formed in 1917, and the dam was built a few years later as a way to provide irrigation to farmers. The area of the district then was approximately 6,000 acres. The dam was dedicated on November 5, 1921. Almost immediately after it was built, the impact of the 39-foot-high dam on salmon runs was felt. In the 1970s, the U.S. Fish and Wildlife Service estimated that 22 percent fewer fish had returned to the basin as a result of the dam. This photograph was taken in 1922.

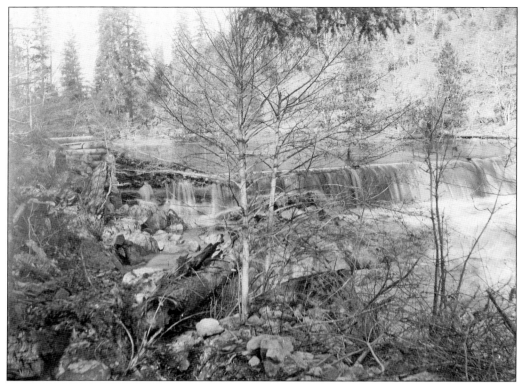

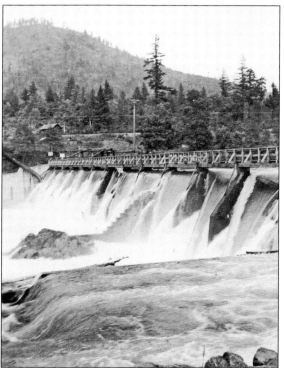

The Old Mill irrigation dam was located at the end of Fielder Creek where it empties into Evans Creek. When this photograph was taken in 1901, it was a log crib dam. This type of dam features a series of log cabin–like structures filled with rocks that are placed across the creek. It was here that Sam Steckel had his water-powered sawmill and where he sawed the lumber for the school and many homes in Woodville. The mill was first built by Davis "Coyote" Evans and purchased by Steckel.

This photograph of Savage Rapids Dam taken in 1938 shows the fish ladders (in the lower part of the picture). WaterWatch and other groups began a movement two decades ago to remove the dam. In 2009, that project will be completed and the dam will be history.

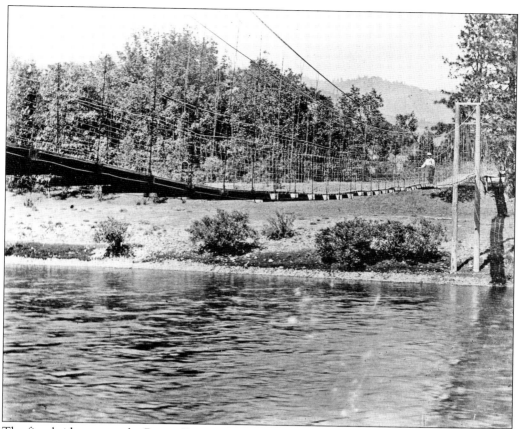

The first bridge across the Rogue River was a swinging bridge built by Ad Helms. It was built in 1897 and was approximately where the bridge is now. There were several swinging bridges in the area, and up until a few years ago, there was still one in use across Evans Creek.

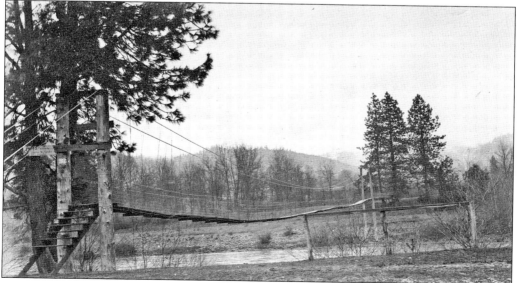

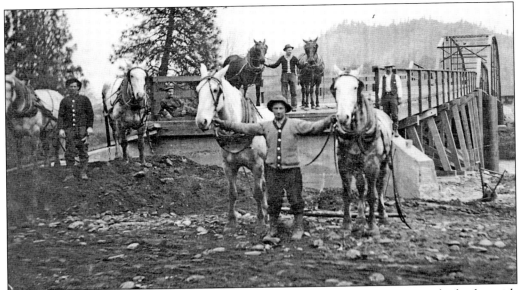

In 1909, the first driving bridge across the Rogue River was built. Working on the bridge with their teams of horses are Charlie Magerle, Fred Neathamer, and Carlos Magerle.

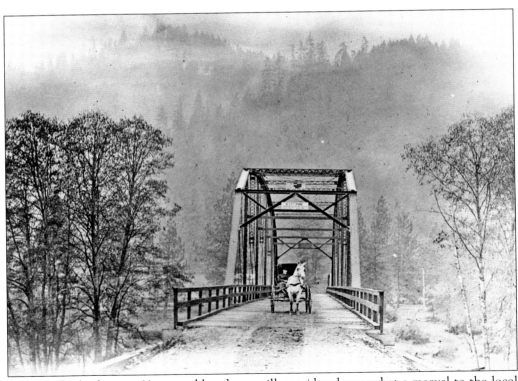

In 1920, the bridge was 11 years old and was still considered somewhat a marvel to the local residents. It was built of steel and people said this bridge was "made to stand forever."

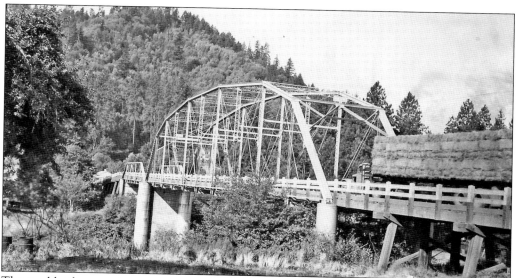

The steel bridge that was "made to stand forever" lasted 41 years and was replaced in 1950 by a larger bridge. The Virginia Bridge Company built the new bridge in 1950. This one lasted more than 50 years and was replaced in 2006 by a cement span bridge.

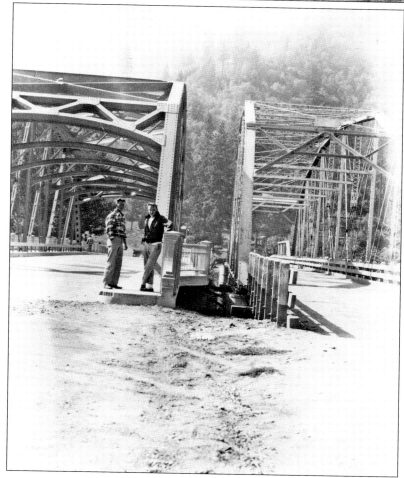

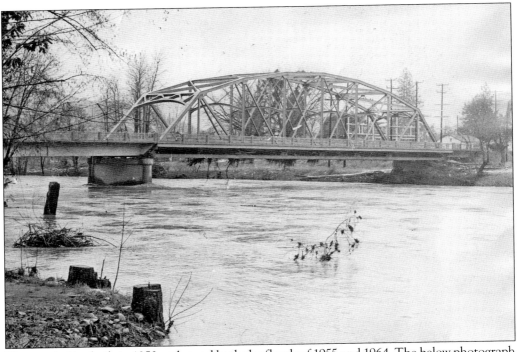

The new bridge built in 1950 withstood both the floods of 1955 and 1964. The below photograph shows Gail's Market and the Bridge Café on the south side of the bridge as they sit filled with water. The flood destroyed many businesses, but the bridge stood firm, even when a house floating downstream hit it and broke to pieces.

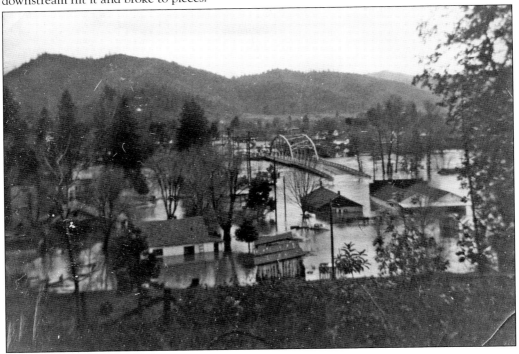

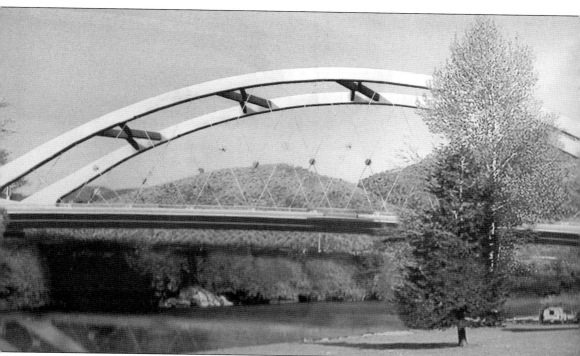

The new bridge was started in 2003 and completed in 2006 and was a feat of engineering. It is a cement span bridge that was built 27 feet upstream from the old bridge. After it was completed, the old bridge was removed and the new bridge was moved into place with the use of hydraulic jacks. (Photograph courtesy of City of Rogue River.)

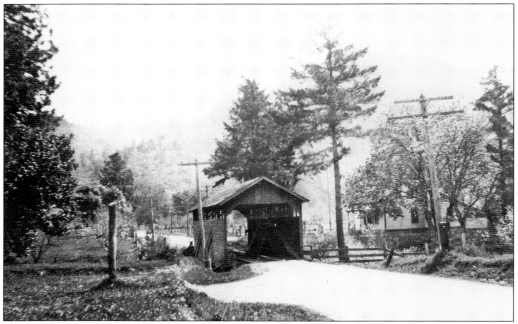

No one seems to know exactly when the covered bridge over Wards Creek was built or when it was taken out, but this photograph was snapped in 1920.

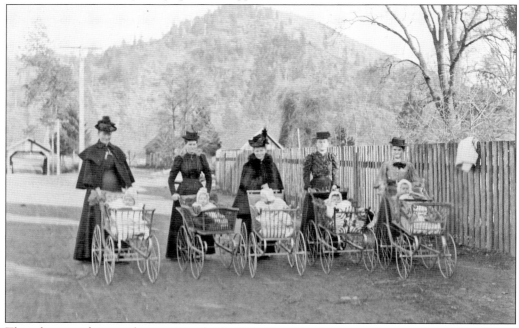

This photograph was taken on March 18, 1899. Five friends are out for a stroll on Main Street with their babies. The Wards Creek covered bridge is in the background. The ladies, shown from left to right, are Angie Wilcox with Lester Wilcox, Bessie Campbell Randall with Bessie Randall Rominges, Gladys Hamen with unidentified baby, Rena Pyburn Whipple with Alice Whipple, and Lillian Pyburn Wright with Hazel Wright.

The Minthorn Bridge was located in Evans Valley and was built in 1913 with timbers that had been taken out of the covered bridge across Evans Creek in Rogue River. That covered bridge had been built in 1868 for the stagecoaches to cross as they headed for the Woods House in Woodville. In 1912, the first cement bridge in Jackson County replaced it. The 80-foot timbers were in such good shape they were moved upstream and used to construct the Minthorn Bridge. The timbers were moved by using a wagon and team with two men to each timber. The bridge remained in use until washed away in the flood of 1964. Several men of the valley tried to secure the bridge with cables but to no avail.

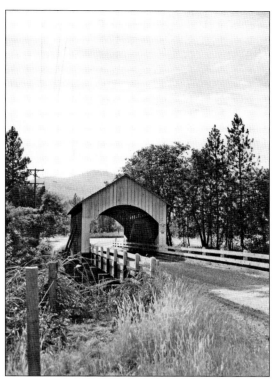

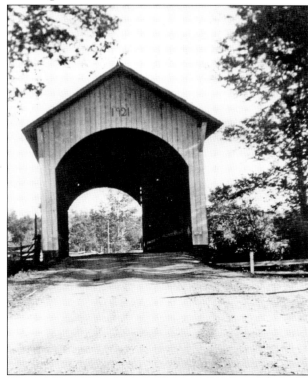

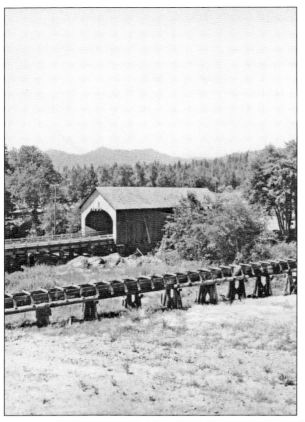

The Wimer covered bridge was built in 1892 and rebuilt in 1927. On July 6, 2003, the bridge collapsed, leaving behind a huge gap in the community, both literally and figuratively. People of the community rallied to replace the bridge. Trees were donated for lumber, fund-raisers were held, and grants were applied for. An exact replica of the original covered bridge was constructed, and on July 6, 2008, it was reopened. There have been numerous events held in the bridge, including Fourth of July dances and "Wimer Day" parades. There have also been three weddings in the bridge. Bruce Sund and Cheryl Martin were the first to be married there in 1991 followed by Jason Menteer and Chelsea Souza in 1999. Sara Sund and Justin McFetridge were the first to be married in the new covered bridge in 2008. (Both courtesy of Cheryl Martin Sund.)

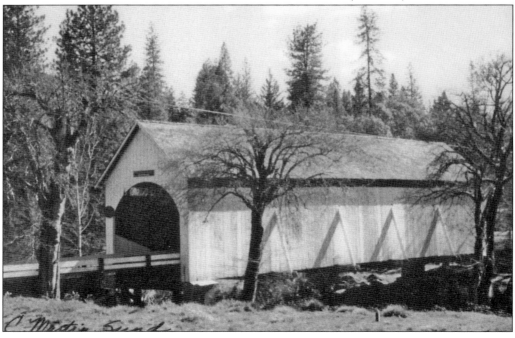

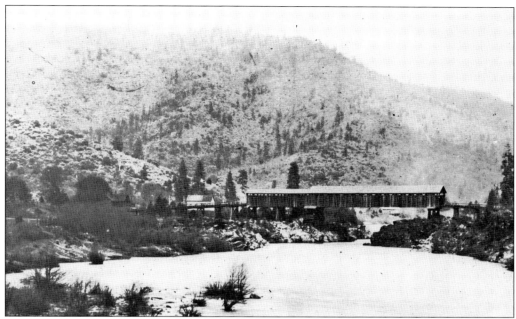

This covered bridge at Rock Point, just south of Woodville, was built in 1880. It crossed the river to the Rock Point stage stop, pictured below. The stage stop was built in 1864 by L. J. White and has now been beautifully restored. It is currently being operated as a tasting room for the surrounding Del Rio vineyard and winery. A cement bridge replaced the covered bridge in 1920, and that bridge is still in use. Conde McCullough, a famous bridge engineer who designed many of Oregon's coastal bridges, built it. It is slated for restoration beginning in the summer of 2009.

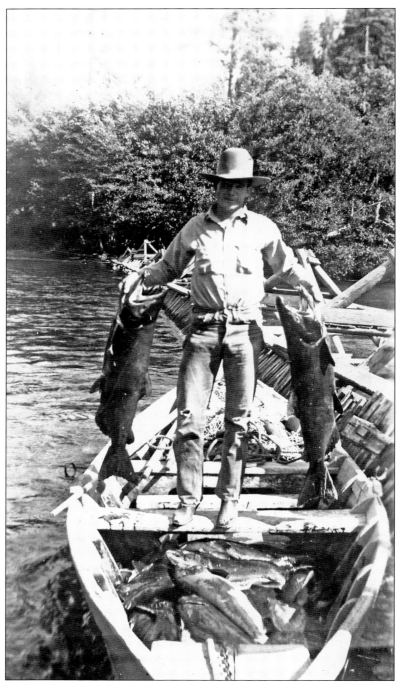

The Rogue River has always been famous for its excellent fishing and can be associated with many famous names, such as Zane Grey and Clark Gable. Both loved getting away to the Rogue on fishing trips. The river sustained many families during the Depression, and some old-timers said they never wanted to eat another fish as long as they lived. Here James Martin shows off his catch of salmon in the 1940s. Notice the ones in the bottom of the boat also.

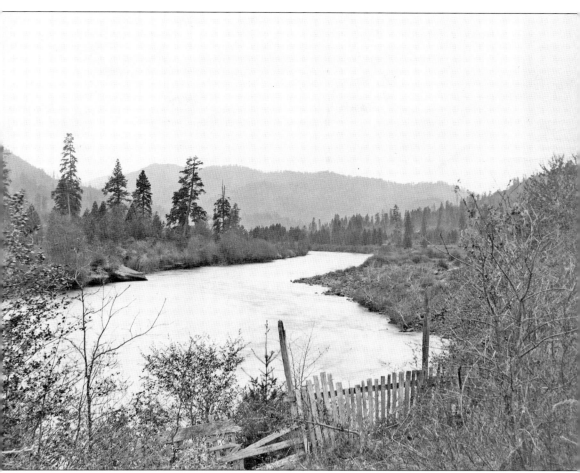

Traveling 215 miles from its headwaters at Crater Lake to its mouth at Gold Beach, the Rogue River is one of the most beautiful and famous rivers in the nation. First known for its gold, it is now known for its whitewater rafting and sport fishing. When Woodville changed its name to Rogue River in 1910, it was because it was proud of the river on whose banks it sat. That pride continues today and will hopefully continue for another 100 years.

www.arcadiapublishing.com

Discover books about the town where you grew up, the cities where your friends and families live, the town where your parents met, or even that retirement spot you've been dreaming about. Our Web site provides history lovers with exclusive deals, advanced notification about new titles, e-mail alerts of author events, and much more.

MADE IN THE USA

Arcadia Publishing, the leading local history publisher in the United States, is committed to making history accessible and meaningful through publishing books that celebrate and preserve the heritage of America's people and places. Consistent with our mission to preserve history on a local level, this book was printed in South Carolina on American-made paper and manufactured entirely in the United States.

This book carries the accredited Forest Stewardship Council (FSC) label and is printed on 100 percent FSC-certified paper. Products carrying the FSC label are independently certified to assure consumers that they come from forests that are managed to meet the social, economic, and ecological needs of present and future generations.

FSC

Mixed Sources
Product group from well-managed forests and other controlled sources

Cert no. SW-COC-001530
www.fsc.org
© 1996 Forest Stewardship Council

Find Your Place in History.